a wedding
like no other

ALSO FROM THE EMILY POST INSTITUTE

Emily Post's Etiquette, 17th Edition

Emily Post's Wedding Etiquette, Fifth Edition

Emily Post's Wedding Planner, Fourth Edition

Emily Post's Wedding Planner for Moms

Emily Post's Wedding Parties

Emily Post's Entertaining

Essential Manners for Couples

Emily Post's Favorite Party and Dining Tips

"Excuse Me, But I Was Next …"

The Etiquette Advantage in Business, Second Edition

Essential Manners for Men

Emily Post's The Gift of Good Manners

How Do You Work This Life Thing?

a wedding like no other

Inspiration for Creating a Unique, Personal, and Unforgettable Celebration

PEGGY POST
and
PETER POST

Collins
An Imprint of HarperCollinsPublishers

HarperCollins books may be purchased for educational, business, or sales promotional use. For information, please write: Special Markets Department, HarperCollins Publishers, 10 East 53rd Street, New York, NY 10022.

FIRST EDITION

Designed by Jaime Putorti

Library of Congress Cataloging-in-Publication Data is available upon request.

ISBN: 978-0-06-122803-2

08 09 10 11 12 WBC/RRD 10 9 8 7 6 5 4 3 2 1

DEDICATION

With gratitude, we dedicate this book to our spouses,

Allen Post and Tricia Post,

and to all of the brides and grooms who have shared their

wedding stories with us.

CONTENTS

CONTENTS

ACKNOWLEDGMENTS

*W*e first want to extend a special thank you to Royce Flippin, whose creativity, organizational skills, and dedication have been paramount in writing our book. Royce's talents, calm demeanor, and cheerful outlook greatly helped us keep this project on track.

Another key person in the creation of *A Wedding Like No Other* is Mary Ellen O'Neill, our editor and friend at Harper-Collins Publishers. From the beginning to the end, she had a vision for presenting these stories in a meaningful way. Mary Ellen: Thank you for inspiring us!

Many thanks, as well, to Laura Dozier and the others on the HarperCollins team for carefully overseeing the production of the book.

The fabulous stories shared with us by brides and grooms are the basis for this book. In particular, we thank the following for providing us with specific details about their weddings: Sara and Nick Finn, Kim and David James, Anne and Tim Connor, Beth and Craig Becker, Emily and David Scheivert, Andrew and Hope Benko, Kimberly and Rodger Griffiths, Ellen and Mazher Ahmad, Karin Warnelius-Miller and Justin Miller, Melita and Christopher Gump, Tatiana and Oleg Butenko.

Thanks, too, to those who offered us their professional expertise. We are grateful for the input received from: the Reverend Robert D. Edmunds, the Reverend Peter O. Plagge, Mark Kingsdorf, Carrie Brown, Dee Merz, and Beth Reed Ramirez.

We also thank Katherine Cowles, our agent, whose encouragement from the very start helped us tremendously. And our heartfelt gratitude goes to our Emily Post Institute associates for their contributions and support as we focused our time and energies on this book: Cindy Post Senning, Tricia Post, Elizabeth Howell, Dawn Stanyon, Anna Post, Lizzie Post, Matt Bushlow, Katherine Meyers, Virginia Keyser, and Alexis Lipsitz Flippin.

And finally, we want to recognize and thank Emily Post, our extraordinary relative. Although she is no longer with us, her compassionate spirit and timeless insights still live on as solid foundations for today's weddings.

A LETTER TO BRIDES AND GROOMS

*W*e can only imagine how excited you must be! A wedding is an incredibly special time in two people's lives, a moment like no other. And *your* wedding will be unlike any other wedding, before or since—a reflection of your own unique personalities, hopes, and dreams.

There are plenty of books (including several from the Emily Post library) that will tell you everything you need to know about the details of planning a wedding. This one is different. In this book, our goal is to get you to put aside your planning lists and must-do's for a few hours, and sit back, relax, and let your imagination soar. It's a collection of stories about *real* brides' and grooms' weddings—each one a "wedding like no other." You'll read about an elopement, a wedding interrupted

by a violent storm, weddings planned on a shoestring budget, and a full-scale gala with guests from all over the globe.

As different as they are, the wedding stories featured here all have something in common: In each one, the bride and groom had a clear idea of what they wanted their wedding to be and were able to stay true to that idea, often in the face of unexpected obstacles. The end result—in every case—was a fabulous and unforgettable experience for the couple and for everyone else involved. Each story is also followed by a short advice section, offering insights on how to stay focused on your own personal vision for your wedding, no matter what challenges might crop up along the way.

We think you'll find the wedding stories in *A Wedding Like No Other* entertaining and heartwarming. We hope they will also stimulate you to think creatively and "outside the box" in planning your own wedding on your own terms. As these stories show, there are many ways to have the wedding of your dreams: All you need to do is to listen to your heart and what it's telling you—and then to follow that path with confidence, imagination, and love.

Best wishes!

Peggy Post
and
Peter Post

a wedding
like no other

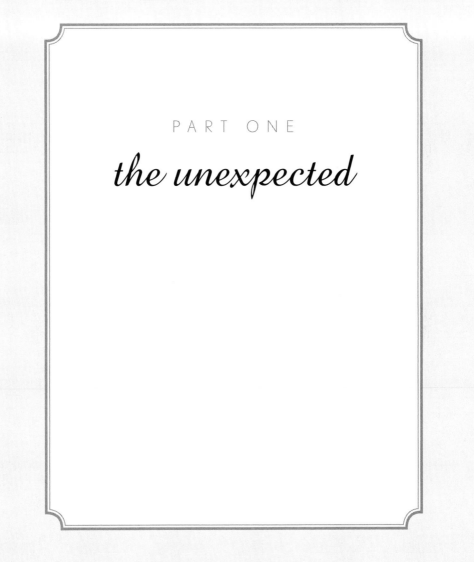

PART ONE

the unexpected

THE NOR'EASTER

*S*ara and Nick had their October wedding mapped out in every detail: They would get married in the Church of the Resurrection in Rye, New York, which Sara had attended all her life, then drive a few miles down the road to a grand old beach club, where the reception would be held in a beautiful setting on the shore of the Long Island Sound. It was the same place where Sara's sister had her reception, and Sara had long dreamed of having her own reception there, too. Her plan was to have the meal in the main clubhouse, with a tent set up on the beach for dancing.

The wedding day dawned to storm warnings: A full-blown nor'easter was heading their way, due to hit sometime in the afternoon. Of course, no one wants rain on their wedding day,

but there was nothing that could be done about it, so the couple shrugged off the news and continued with their final preparations.

"The first sign that the storm might be more serious than we thought was when the tent company called, early in the afternoon," remembers Sara. "They told us the wind was too strong to put up the tent on the beach. The sky was very overcast, but it hadn't started to rain yet. My attitude was, 'Come on, the storm hasn't even hit.' But I guess they knew something we didn't."

By the time Sara, Nick, and the rest of their wedding party drove to the church for the three o'clock ceremony, the day had turned almost pitch-black and the first drops of rain had begun to fall. "I left the house with a garbage bag held over my head," says Sara. "Still, everyone got to the church okay, and the ceremony went off without any problems until just before I was supposed to walk down the aisle. That's when the lights went out." Since Nick's family had been talking about dimming the lights during the ceremony all along, Sara's first thought was that this was just part of the ceremony—until the priest stopped the service and called for candles to be given to the bridesmaids for their walk down the aisle.

"Along with the candles on the altar, and more candles in the back of the church, it looked incredibly dramatic," said

Sara. "When the ceremony was finished, we rushed out of the church and discovered the storm had gotten really scary. The wind was blowing incredibly hard, and the rain was falling sideways."

Snug inside their limo, the couple headed down the beach road leading to their reception site, their 250 guests trailing behind. Not far from the club, they ran into a police roadblock—a tree was down, blocking the way. Undaunted, they reversed course and tried the only other approach to the club. Again, they encountered a fallen tree that made the road impassible.

Unsure what to do—and with their food, flowers, wedding cake, and dance floor all waiting out of reach at the beach club—the wedding group turned their cars around and made their way through the driving rain to the house of Sara's parents. "That's when we lost a lot of the people who'd been following us," says Sara. "This was ten years ago, before everyone had cell phones, and the storm was so bad that people were reluctant to get out of their cars to find out what was going on."

Sara's father made a call to another nearby club, where he was also a member—and where Nick's family and a number of other guests were staying—to ask if there was any way they could a host a last-minute wedding reception. The club's event manager told him that there was already another formal wedding reception underway in the club's main dining area, but

that they could use the casual "19th Hole" bar and grill area on the lower level, where, on sunnier days, club members relax and unwind after playing a round of golf.

"It's a pretty small space, with faux-wood paneling, a low white ceiling, and a huge bulletin board for club announcements—very different from the beach club, which is really beautiful," says Sara. "But we were *so* glad to get there."

By the time the bride and groom showed up, everything had been prepared: The events manager and the club's chef had raided the club's refrigerator and freezer for any food they could get their hands on, and the chef had immediately gone to work on his massive grill, whipping up a full buffet of fresh-cooked food, which was set out and waiting for the guests as they arrived. "The moment we walked in, we knew everything was going to be perfect," Sara says. "It was incredible how they pulled it together."

With the help of family and friends, the couple had been able to contact about half of their guests in person or by phone to let them know about the change in venue, and a hundred-odd people—some of them in jeans, having returned home only to be evacuated because of rising flood waters—were now packed into the lounge, enjoying the food and the open bar, eyeing the storm that raged outside the picture windows and dancing wherever they could find the room.

While the original musicians Sara and Nick had hired had given up in the storm and gone home, it turned out that the musicians playing at the reception upstairs were members of the same band—and so they arranged for three or four musicians at a time to slip downstairs and play at Sara and Nick's celebration. Meanwhile, another guest had ventured out in the storm to a nearby store to get a chocolate ice cream cake with an oreo-crumb topping, which served as the couple's wedding cake.

"Everyone just had the best time. They all kept saying 'This is the best wedding in the world,'" Sara remembers. The highlight of the evening came when the couple in the ballroom invited Sara and Nick to have wedding pictures taken with *their* cake before it was served. Sara says that these shots are among their favorite memories.

Looking at the photos of their reception (the photographer made it to the reception, albeit a bit rumpled from the storm), Sara's strongest memory is of how happy everyone was to be there. "It's so easy to get caught up in relatively unimportant things, like what china to register for," she says. "Our wedding taught me how important it is to keep everything in perspective. At the start of the day, I'd been feeling very nervous about being in the spotlight. The storm and everything that followed forced me to relax and remember that it's really

all about sharing a special moment with the people you love—wherever that might be."

SARA AND NICK'S MOST MEMORABLE MOMENT: *"At a certain point in the party, when we looked up and saw everyone dancing together, with the rain beating down outside—knowing they were truly enjoying the day and our marriage, despite the horrendous weather—it was the most wonderful feeling in the world!"*

Coping with Last-Minute Emergencies

Your photographer has fallen sick—or the baker's van got into a fender bender, destroying your wedding cake, or the imported flowers you had your heart set on haven't materialized, or, worst of all, your reception venue has suffered a ceiling collapse, or a burst pipe, or—like Sara and Nick's beach club—is unreachable across flooded roads. In even the most carefully planned wedding, things big and small can go wrong at the last minute. So how to take these emergencies in stride, while still making sure that no important elements go missing?

Wedding professionals agree that when a last-minute emergency rears its ugly head, that's the one time above all when

you should turn to . . . a wedding professional, of course. If a professional vendor can't come up with a certain food or floral item or has an equipment malfunction, it's the vendor's responsibility to come up with a replacement—and in fact, an experienced pro will already have backup plans in place. The same holds true when a vendor has to cancel because of illness or a family emergency: Any professional worth his or her salt is certain to have fellow professionals that they can ask to fill in for them at the last minute.

For bigger catastrophes, you may need more high-powered assistance. "If you've suddenly lost your reception site just days before your wedding, the first thing I'd recommend doing is to call a wedding consultant," says Mark Kingsdorf, owner of the Queen of Hearts Wedding Consultants in Philadelphia. "A consultant will provide a calm, objective perspective at a time when you're likely to be sweating bullets, and can also be very helpful in tracking down a replacement venue. In fact, if it's just a matter of spending a few minutes of networking to find an available site, a lot of consultants will be glad to help out for free."

An experienced consultant, explains Kingsdorf, will have connections to literally hundreds of venues and vendors. "For example, I have seventy wedding photographers in my network

area," says Kingsdorf. "Even if one of the connections I have isn't available, chances are they can recommend someone who is."

Another option is to ask the wedding professionals you've already hired for suggestions on last-minute replacements for a reception site, vendor, or item. Most site managers at a hotel, restaurant, or reception hall will have their own list of contacts that will serve as a valuable starting point in your search. The same goes for caterers, photographers, and DJs. To be on the safe side, you should always carry a list of all your vendors' phone numbers with you in the weeks leading up to your wedding, in case you need to contact one of them quickly.

The prospect of a last-minute emergency is also a good reason to think twice about having friends or family substitute for professional vendors. "If a professional baker drops your wedding cake, he'll always be able to put together something that works," says Kingsdorf. "But if someone's cousin is making the cake and something happens to it, then you're looking at a supermarket sheet cake for your wedding."

Besides knowing where to turn for help, your own attitude is also important. When things go wrong just before a wedding, here are some tips on how to help right them:

✳ *Stay calm and keep the "big picture" in mind.* In the case of Sara and Nick and their families, they never allowed the severe weather and the sudden setbacks it caused to dampen their spirit and enthusiasm for their wedding and all it meant to them.

✳ *Assess your options and look at all the alternatives.* While the possibility of postponing Sara and Nick's reception was discussed, Sara's father refused to give up on the idea of having their reception as scheduled. With a little ingenuity, he was able to line up a different site at the last minute.

✳ *Accept help from friends and family.* By enlisting the help of those close to them, Sara and Nick were able to contact a sizable portion of their guest list to let them know about the change in venue.

✳ *Be ready to adjust your expectations.* Sara's heart had been set on an elegant location. Instead, she ended up with a much more casual setting, food that had to be defrosted before it could be grilled, and a wedding cake that was a far cry from the one they'd planned. Yet the wedding day turned out to be "perfect."

✳ *Seize the magic of the moment.* Sara and Nick borrowed another couple's wedding cake for their wedding pictures. Musicians showed up to play through sheer serendipity. Guests made room to dance wherever they could. And the result was an especially memorable, happy occasion.

THE WORLD TURNED
UPSIDE DOWN

*K*im and David finally decided to tie the knot in July
of 1984, after a courtship of eleven years. "I couldn't
believe I'd finally landed him," laughs Kim. "He was such a
confirmed bachelor."

Before telling anyone else about the engagement, David
had insisted on asking Kim's father for his blessing. "Naturally,
my father was thrilled that we were finally getting married,"
says Kim. They agreed that the marriage ceremony would be
an intimate affair, attended by family only, and that they'd
throw a big party for friends and extended family on the day
after the ceremony. "To me, wedding vows are very private and

personal," Kim says. "I didn't want our ceremony to be a public spectacle. Luckily, David felt the same way."

Their big debate was over where to hold the ceremony. Originally they'd planned to get married at city hall in San Francisco, the city where they'd been living for the past seven years. "Joe DiMaggio and Marilyn Monroe were married there," says Kim. "It's a gorgeous building, and the perfect symbol of San Francisco, a city we'd come to love deeply."

When David announced their engagement to his family, however, they made it clear that they badly wanted a church wedding. As a child growing up in London during World War II, David had been evacuated to the countryside to escape the Nazi bombing raids. He lived for several years with the family of his uncle, who was an Anglican vicar. His uncle and aunt were like second parents to him, and their family felt that for the wedding to have religious significance, a church ceremony was a must-have.

Unsure what to do, Kim turned to her father for advice. "He was a terrific dad, and very wise," she says. "He weighed everyone's desires, and then asked me if David's family's reasons for wanting a church wedding, which went to their deepest beliefs, seemed more important than my reasons for not wanting one."

Taking her father's words to heart, Kim gave in to her fiancé's

family, and she and David started looking at different Episcopal churches in the Bay Area, including the imposing Grace Cathedral in San Francisco's Nob Hill neighborhood. But given the intimate ceremony they had in mind, getting married in the huge nave of the cathedral was out of the question. Then they spoke to the cathedral staff and found out they could use the Chapel of the Nativity, a small chapel in a niche on the right side of the main church. Lined with paintings, tapestries, and other artwork, it was perfect for their family group.

In the meantime, they also made arrangements to hold a large reception the day after the ceremony in the rooftop garden of the Kaiser Building in Oakland—a legendary space that was at one time the largest roof garden in the world. As their plans progressed, though, another complication developed: Kim's father had been diagnosed with lung cancer, and in the weeks leading up to the wedding his health began to deteriorate sharply. By the time David's family arrived from England for the ceremony, Kim and David were spending most of their time and energy caring for her father in the hospital.

Realizing her dad would be too weak to walk Kim down the aisle, the couple met with Janet, the Episcopal priest who would be marrying them, and agreed on an alternate plan for the ceremony, in which Kim's father would wait for her at the altar and then give her away.

Several days before the wedding day, Kim's father appeared to take an abrupt turn for the better. Relieved, Kim and David finally were able to give their full attention to David's family. They decided to take their visitors on a short pre-wedding trip up north to the wine country. When they got back to San Francisco, they learned that Kim's father had just lapsed into a coma. He never recovered. In the early morning hours of July 4, two days before his daughter's wedding, he passed away.

Suddenly, Kim and David's world was turned upside down. "Since he'd been doing so much better, we were really expecting him to be there with us at the ceremony," says Kim. "Now we had to decide whether to go through with the wedding at all."

After a lot of soul-searching, Kim and David made the decision to go ahead with the wedding as planned. "After all, David's relatives had already come over from England," Kim says. "And even though I know it sounds corny, I really think my dad would have wanted it that way. He was absolutely ecstatic that we were finally going to be married."

Now that she'd made the difficult choice to go through with the wedding, Kim found herself face-to-face with another emotional dilemma: With her father gone, who would give her away at the ceremony? The priest asked her if she wanted her mother to stand in. "That just didn't feel right to me," says Kim. Then

the priest suggested that one of her brothers do the honors, but again Kim said no. Finally, Janet had another thought: "What if your whole family gave you away?" she said.

"Can we do that?" asked Kim.

"It's your wedding," smiled Janet. "You can do whatever you want!"

And so, on their wedding day, Kim and David found themselves standing in their little chapel surrounded by their closest family members: David's aunt, his cousin (who was like a sister to him), and the cousin's husband; and on Kim's side, her mother, sister, two brothers, and her brothers' wives.

"I was sad, but happy at the same time," says Kim. "I was so glad it was finally happening—but there was such a huge hole with my father's absence. During the service, Janet said something about my father not being there, and everyone had to take a moment to compose themselves. It was just so tragic—of all days, this was the one where I really wanted my father to be at my side."

Then, as sunlight streamed through the stained glass, the priest reached the point where she asked, "Who gives this woman to be wed?" And a family of voices swelled up in unison, "We do!"

"It was perfect," says Kim.

The families went out to a celebratory lunch at a beautiful

landmark San Francisco restaurant, then regrouped across the bay for the big party the next day—an afternoon gathering of 150 guests in the Kaiser Building's rooftop garden, a private and beautiful spot complete with trees and an actual pond with a footbridge running across it. The band started out playing Gershwin tunes, then segued into some modern rock numbers as Kim and David's guests danced and mingled, toasting the newly married couple and enjoying hors d'oeuvres catered by a restaurant in the building. On the horizon, the sun made its leisurely descent into the Pacific, casting a golden glow over the celebration.

"It was a fabulous party, and a wonderful wedding," says Kim. "And David and I managed to have a great time through it all—despite the loss of my dad."

KIM AND DAVID'S MOST MEMORABLE MOMENT: *"The moment during the ceremony when we both said 'I do.' We were so thrilled that it had finally happened!"*

Dealing with Sad News in Happy Times

The wedding is only days away and someone close to you falls seriously ill, or there's a family spat, or, worst of all—as in Kim and David's case—a parent suddenly passes away. Do

you carry on and get married as planned, or cancel your wedding date and reschedule? If this sort of unexpected dilemma should arise on the eve of *your* wedding, you'll find that it presents a true test of grace under pressure. This is a time for being extra sensitive to others, making difficult decisions as quickly as possible, and communicating clearly and honestly.

The following is a step-by-step process for dealing with an unexpected family crisis that occurs just before your nuptials, whether it's a death (the example used here), a sudden illness, a divorce, or a family rift:

* First, fully explore your own feelings and those of your betrothed. Decide whether the two of you feel comfortable going through with the wedding plans on the original date.

* Next, consider how a change would affect others. Start by conferring with your loved ones: Express how the situation is affecting you, and find out what your family members are thinking. Listen carefully to how they are dealing with the sudden turn of events, and ask them for their opinions regarding whether to go ahead with scheduled plans or to postpone the wedding.

✳ Weigh the various opinions of your families. Figure out what makes the most sense in the face of this particular situation: It may be that the majority of your family members are too upset to go through with the celebration of your marriage at this time. On the other hand, it could be that a wedding is just the right salve for cheering everyone up. Perhaps you'll collectively decide that, in the face of the loss of the loved one, you're all in agreement that the deceased would have wanted you to go ahead with the wedding plans.

✳ In making your final decision, think about your guests' needs and wishes as well. Some may have already traveled some distance to be at the wedding. Others might find that their travel plans would be difficult and/or expensive to change at this point.

✳ If you wish, turn to your clergy person or other mentor/confidant for counsel. Such a person can be extremely helpful in offering objective advice based on insightful experience.

✳ Explore the practical aspects of your decision. If you're thinking about postponing the wedding and reception,

find out from the professionals you've hired whether: 1) alternate dates are available, and 2) monetary penalties would be imposed if you were to change the terms of any contracts.

✳ If you've decided to go ahead but want to make certain changes to the ceremony or reception, confer with your officiant and close family members. Determine what feels best to you and what would make others feel comfortable. Then embrace any such changes with confidence—as Kim did with her decision to have the members of her family "give her away."

✳ Once you've made your decision either to go ahead with your original wedding plans or to postpone them, seize your choice with gusto. Be confident that you have made the right decision: Look forward, and enjoy your big day!

Spreading the Word

If you decide *not* to postpone your wedding, there's not much you'll need to do to spread the word about the problem at hand. The news will get around naturally on its own.

In the case of a postponed wedding, you and your fiancé/ fiancée ideally should try to select an alternate date right away. If you're able to do this, then all invitees can be informed of both the postponement and the new date at the same time. In any case, all guests and wedding professionals must be told of the postponement immediately.

Your first priority should be to get the word out at once via telephone or e-mail to any professionals and vendors you've hired. In addition, you should make it a point to speak personally with your officiant. As for your guests, you should let them know in the fastest, most practical way possible: Phone calls, e-mails, or breaking the news face-to-face are all fine. If you plan to pass along the news over the phone, you can recruit close friends or relatives to make some calls if you wish. If you decide to inform people via e-mail, do so only with people who check their e-mail accounts frequently. You would also be wise to ask each person to e-mail confirmation that they received your message.

If time allows, you can also spread word of the postponement via a written note or printed announcement. Here is an example of how such an announcement might be worded:

Sample Postponement Announcement

Mr. and Mrs. James Martin
announce that
the marriage of their daughter

Susan Marie
to
Mr. Robert Jones

has been postponed to September twenty-fifth
at four o'clock
Waterbury Congregational Church
Kansas City, Missouri

WINE CELLAR MAGIC

*W*hen Anne and Tim tied the knot, it was the second marriage for both of them—"One for practice, one forever," as they like to say. Anne's first wedding had been a huge affair with 300 guests, half of them people she didn't know. This time, both the bride and groom were determined to do things their way. Like their relationship, their wedding would be a warm and happy occasion—one that was elegant, fun, and memorable, but at the same time, just a little bit different. "Traditional, but with a twist—like my engagement ring," explains Anne. "It has a diamond, but it also has a prillion sapphire on the side."

Then again, what else would you expect from a couple that met in the Fort Lauderdale airport, waiting to board the same

overbooked plane? "I saw this attractive guy reading the newspaper and figured that looking at him was as good a way to pass the time as any," says Anne. "Then he put his paper down and caught me staring." They both laughed and then fell into conversation—finally parting ways when Anne got a seat on the plane and Tim didn't.

"There was a very definite chemistry between us," Anne recalls. "I hadn't felt that way in quite a while." When she got home, she went to the library and looked up his address in the telephone book for Tampa, his hometown, then sent him a playful postcard—with no return address or phone number. Tim, up to the challenge, found a San Francisco phone book with Anne's home address and penned a reply.

For a year the couple maintained a long-distance relationship, until finally Anne invited Tim out to northern California for a visit. One of their first dates was a trip to Napa Valley, where they ventured into the V. Sattui winery in St. Helena. A family-owned vineyard founded in 1885, with classic old stone buildings surrounded by two acres of shaded picnic grounds and thirty acres of grape vines, V. Sattui is like a small medieval village. It's the kind of place where, after a day of touring other nearby vineyards, wine connoisseurs like to come and relax, drink the highly regarded V. Sattui wine (sold only at the winery and nowhere else), and nibble on goat cheese,

sun-dried tomatoes, and other goodies from the winery's gourmet cheese shop and deli.

V. Sattui is also a well-known wedding site, and when their romance had blossomed into an engagement, Anne and Tim didn't think twice about where they wanted hold their ceremony and reception.

"Besides the meaning it held for us, one of the attractions about V. Sattui was that people would be able to enjoy some great wine that they can't get anywhere else," says Anne. "Another nice thing is that the nearby hotels had a two-night minimum, so the guests who came to our wedding were making a commitment to stay for the whole weekend. It's a very relaxed area, and a great place for people to enjoy themselves. You can go wine tasting, hiking, cycling, horseback riding, go to a spa, play golf, even ride in a hot air balloon."

Anne and Tim worked with the winery's wedding planner, an experienced, take-charge woman who handled every detail. She helped them map out a menu for their sixty guests, picked several area photographers for them to interview, and even found a local minister to perform the ceremony.

"The planner was just terrific," says Anne. "She told me, 'Anne, here are the things you need to decide; I'll take care of the rest.' I didn't want to have to be concerned with any of the nitty-gritty stuff—it would have driven me *insane*. I was there

to get married, period. I've been at friends' weddings where they worried about every last thing, and barely remember their wedding. My wedding was just the reverse: All I cared about was that the guests had wineglasses to drink from and a comfortable, inviting environment to enjoy themselves in."

The couple's plan was to have the ceremony and reception outdoors on tables set in an open meadow. But when they woke up on the morning of their wedding day, they found that the normally mild Napa Valley weather had given way to howling winds. "The wind was literally so strong that it could have knocked you over," recalls Anne. "I just lay in bed and said 'Oops, I guess this will be an issue.' But the beautiful thing was, I didn't worry for a minute. I knew our wedding planner would come up with a solution. And I also knew that, with all the winery's wonderful old stone buildings, there were no bad options."

As the wedding's afternoon start time approached and the winds continued to roar, the planner came up to Anne and Tim and announced, "We're taking it indoors to the wine cellar." The location she had in mind for the ceremony was a private tasting room, which led through double doors to a larger room with a dance floor where the reception would be held.

"The tasting room was a small, dark space—it smelled musty in a good way, like a good bottle of wine," says Anne. "It was the exact opposite of the expansive meadow where we'd

originally planned on getting married. But the intimate feeling was just right." A spiral staircase in the corner led up to the main winery, and the planner had arranged for votive candles to be set on each step. As the guests sat surrounded by large oak wine barrels, Anne's bridesmaids walked down the aisle between them, dressed in white dresses with black polka dots, and preceded by nieces and nephews carrying wands with polka dot streamers instead of flowers.

Next came the bride herself, escorted by her father. "It's one of my favorite photos from the wedding," says Anne. "My dad is British, very proper and not one for the spotlight—but the shot of him walking me down the aisle is fantastic. He looked so happy and proud."

Anne and Tim had designed their own short service, with traditional vows. "My only requirement was that they not include the word 'obey,'" says Anne. "The minister chuckled about that during the ceremony. He was very funny, and he really got what we were all about."

Following the ceremony, the couple and their guests went into the next room to dance and feast on shrimp, crab claws, bruschetta, roast beef, and a "small but lovely" three-tiered wedding cake topped with purple Napa Valley grapes—all accompanied, of course, by wine from the V. Sattui vineyards.

"Another one of our favorite photos is of Tim and me toasting each other. We were completely unaware that we were being photographed," says Anne. "It was candid and relaxed, which is the way we live our life together."

For their guests, it was the culmination of a perfect weekend. "Afterward, a number of people told us they hadn't had a romantic getaway like that in a long time," says Anne. "One couple even said it was like a second honeymoon. Tim and I felt great that, while we were celebrating our own connection, we were also helping other people renew their own connections."

To this day, says Anne, people tell her how vividly they remember that weekend, and how much they enjoyed the area and all it had to offer. "I've known weddings where it was all about the bride. This one was about all of us who were there, celebrating the fact that Anne had finally found the right guy."

In the weeks that followed, Anne's niece, then four, delighted in informing everyone back home in Wisconsin that her auntie and uncle were married in a cellar. "I'm sure everyone was picturing a wedding in a typical Wisconsin basement!" laughs Anne. "But we couldn't have been more pleased with the setting and the mood—and the fifteen years so far

that have followed. Sometimes, the unexpected can be the best surprise of all."

ANNE AND TIM'S MOST MEMORABLE MOMENT: *"Standing in the courtyard of our hotel, which was located just outside the winery. It was a very rustic place—every room had a fireplace—and Anne had just put on her wedding dress and was getting ready to go to the ceremony. Our nieces and nephews were running around with their wands, the bridesmaids were there, everyone was laughing. This couple that we didn't know was walking along the balcony above us, and they leaned over the railing and said to Anne, 'You look so beautiful.' And at that instant, we just knew that we were in the right place, at the right time, doing the right thing."*

Choosing an Unusual Wedding Site

These days, getting married in an exotic location—whether it's a northern California winery, an island beach, a European villa, or an uncommon venue closer to home—is no longer the rare exception but rather a growing trend. After all, an unusual setting is a great way to set your wedding apart and to share in an especially memorable experience with your friends and family. In fact, many resorts and other tourist destinations

now actively cater to couples seeking to tie the knot. If you can imagine a location in your mind's eye, odds are you can get married there.

That said, it's important to remember that, in many cases, choosing a distant or difficult-to-reach wedding site will tend to limit the number of invited guests who are able to attend. Often, this is part of the appeal of the exotic wedding site: It automatically creates a more intimate wedding, while insuring that the people who show up are those who truly care about sharing in the event. Plus, those guests who do make it are sure to have a memorable time. Still, it's important to think this factor through before settling on your unusual wedding locale, taking special care to talk your decision over with close family and friends who you know will absolutely want to be there with you on your wedding day—wherever *there* happens to be. There may be those who will simply be unable to join you; their absence could well be a major disappointment for all of you.

If you're thinking of getting married in an unusual location, we suggest you reserve your site well ahead of time (at least six months in advance)—and even more if you're thinking of getting married in a popular month, like June or September, or are considering a venue in a populous city—on the chance that some other couple may have the same idea. This

will also give you plenty of time to work out your food and beverage service and line up someone to perform the ceremony. In addition, if your location requires guests to make airline and hotel plans, they should be informed of the locale and provided with travel and accommodation options at least several months in advance, so they can make the necessary arrangements.

Now, for all you brides and grooms with a yen for something a bit off the beaten track, here's a list of venue ideas to get your creative juices flowing:

DESTINATION WEDDINGS. Nothing sends a spark of excitement through a wedding guest list like an invitation to a wedding abroad. Favorite sites include the Caribbean, Hawaii (especially Maui), Bali, Tuscany, Paris, Germany's Black Forest, Martha's Vineyard, northern California's wine country, Disney World, and the ever-popular Las Vegas. The key challenge for many of these destinations: Finding an on-site representative to coordinate your wedding plans for you.

RESORT WEDDINGS. These also fall under the category of destination weddings, but in this instance the wedding takes place at an established institution with experience in hosting wed-

dings. Popular venues include established sun-and-surf chains like Sandals and Beaches, large ski resorts like Aspen and Breckenridge, the major Las Vegas casinos, and wedding sites at theme parks like Disney World—where the pre-planned wedding options include a stylized "fairy tale" wedding in Cinderella's castle. Key challenge: Placing your own individual stamp on the wedding, rather than simply following the resort's standard format.

THE SHIPBOARD WEDDING. This variation on the exotic wedding-locale theme is another one that's gone from being "way out there" to the point where it's now virtually mainstream. Many newer ships even have built-in wedding chapels, and all of the major lines offer wedding packages that include a civil ceremony, wedding cake, champagne, flowers, and photographs, typically at a cost of under $2,000. Note that ceremonies cannot be performed at sea but must take place while the ship is docked. Many cruise lines will also offer on-land ceremonies at selected ports. Holland America even features a glacial wedding package in which the couple is transported via helicopter to the top of a glacier near Juneau, Alaska, where the ceremony takes place. Key challenge: Finding someone to marry you. Contrary to popular myth, most ship's captains do not perform weddings.

THE TRULY UNUSUAL DESTINATION. Want to get married in a ruined Scottish castle, or at a lookout point a mile's hike from the road in Yosemite National Park, or in a submarine off the coast of Maui, or at Stonehenge? These have all been the sites of recent weddings. Again, if you can picture it, it can probably happen. Key challenge: Matching the style of wedding you have in mind to your chosen destination—especially if it's a place that requires traveling on foot to get there.

THE UNUSUAL SETTING CLOSER TO HOME. Zoos, aquariums, botanical gardens, museums, concert halls, sports stadiums, tops of skyscrapers, railway and subway stations, river and lake boats, roller-skating rinks, the finish lines of road races— all have been successfully employed as hometown wedding venues. Some standouts are: the couple that got married eighteen stories above Puget Sound, in the middle of the Tacoma Narrows Bridge, and the pair of hockey fans who were wedded on an ice rink while wearing full hockey regalia. The more the venue is geared to hosting weddings, the better the experience is likely to be. The Cleveland Zoo, for example, can seat up to 300 guests for a sit-down wedding dinner in its rain forest—plus the $3,000 rental fee gives guests their private run of the entire zoo for the evening. Key challenge: Making sure your unusual local site is available on the date you've picked, and that it

can comfortably handle the number of guests you have in mind.

THE "MYSTERY LOCATION." This approach is especially popular in Great Britain. Guests are told to show up at a certain address, where they are then transported by bus, boat, or other conveyance to another, unknown, site where the wedding celebration is to take place. One British company, called Wedding World, will even plan the whole event for you, right down to designing and sending out cryptic invitations. Key challenge: Convincing your spouse that this is the way to go.

THE REALLY OVER-THE-TOP WEDDING VENUE. For the truly adventurous, there's always the option of getting married in a hot air balloon, or while riding on a roller coaster, or (gulp) in midair after jumping out of an airplane—while wearing a parachute, of course! Scuba enthusiasts might also consider emulating the couple who got married underwater a few yards off the beach in St. Croix, with over 100 other oxygen-tank-wearing guests in attendance. Key challenge: Finding family members and friends—not to mention an officiant—willing to go along with your creative plans.

PART TWO

with a little help
from our friends

UNDER THE CANOPY

*B*eth and Craig couldn't have picked a more picture-perfect setting for their wedding: The Winterthur Museum and Gardens, in Delaware's Brandywine Valley, is a 1,000-acre estate, which was once the home of the fabulously wealthy Henry Francis du Pont. The turn-of-the-twentieth-century mansion at the estate's center, which had been built by du Pont to house his extensive collection of Early American decorative arts, was designed to recall the great European country homes of the eighteenth and nineteenth centuries. The estate's garden and grounds reflect du Pont's deep interest in horticulture—a passion that began in childhood. Over the years he selected and imported plants from all over the world, planting them in carefully planned patterns to showcase their colors and seasons in bloom.

When Beth and Craig were deciding where to get married, Winterthur was a natural choice. The estate specializes in hosting weddings in the evenings, when the museum-goers and other tourists have left for the day, and it was a place that Beth knew well. As a graduate student in history, she'd taken several courses at the museum and had been blown away by the place's beauty, not to mention the quality of its cuisine. "The chef there is *really* excellent," she says. She was also attracted to the sixty-acre Winterthur Garden, which she knew would make a perfect backdrop for wedding photos.

Since Winterthur has an experienced planning staff, no one would have blamed the couple for sitting back and letting the Winterthur team handle the whole show. But Beth and Craig wanted to put their personal stamp on their wedding—and, like the estate's guiding spirit, Henry du Pont, they had a strong creative vision of how this could be accomplished.

And so, starting a year before the wedding, they began planning a number of added touches that would transform their wedding into a one-of-a-kind event. "My mother and I are both very arts-and-crafty, so we set out to make as many things ourselves as we could," says Beth. "My mom crocheted yarmulkes for all of the male guests to wear at the ceremony in our wedding colors of lavender and green."

Beth and Craig also made their own wedding invitations,

using the same lavender-and-green color scheme to create a design featuring a gate made of layered squares that opened onto the cream-colored invitation itself. In addition, they handmade the place cards and table cards for the reception, naming each table after a famous historical couple, such as Antony and Cleopatra and John and Abigail Adams. "My husband majored in history before going to law school, and we're both big history buffs," says Beth.

The table centerpieces were made of lavender and green flowers surrounding a metal sculpture of a couple. Beth continued the color theme by using lavender and green ribbons to make headpieces for both mothers' crowning ceremonies. It's a Jewish tradition to crown a mother at the wedding of her last child, as a sort of "job well done" gesture—and as it happened, both Beth and Craig were the last children in their respective families to tie the knot.

With all these remarkable personal touches, however, one item stood out above all the rest: Beth and Craig had asked the people closest to them each to design their own twelve-inch-by-twelve-inch square of fabric, to be incorporated into the covering of the chuppah—the traditional canopy that the bride and groom stand beneath during a Jewish wedding ceremony.

"In the Jewish faith, the chuppah represents the home that

the bride and groom will build together," says Beth. "About six months before the wedding, we sent out packages to our immediate family and the members of our wedding party. Each package contained a square of muslin, a letter from Craig and me explaining what the square would be used for and asking each person to decorate their square any way they liked, and an addressed, stamped envelope to send the finished square back in. We gave everybody a deadline of two months before the wedding."

The couple sent out twenty-four squares. Within a month, they began getting the finished squares back in the mail. "I was a little worried when they first started coming in—the squares were all so very different, I wasn't sure how they'd work together," says Beth. "There were a lot of different colors and styles: Some people painted on the fabric, others did appliqué or iron-on transfers, and a number of people did designs that were fairly three-dimensional. But then, as Craig and I received more and more squares, we realized how perfect it was that they were so diverse and varied. Each square really reflected the personality of the person who made it."

A month before the wedding, with all the finished squares in hand, Beth and her mother sat down to stitch them into a quilt, adding four rings to the corners so it could be hung from four poles. (After the wedding, they would add filler material, so the couple could enjoy their friends' creations for years to come.)

"We had to figure out the best way to fit all the squares together," Beth says. "Some were meant to go next to each other, like the squares from my aunt and her three children, which spelled out the four words BETH CRAIG TRUE LOVE, with other words and flowers leading out of them."

Craig's mother and grandmother both embroidered messages, while one bridesmaid sewed on cutouts of the North American and African continents (Craig was born in South Africa) with a heart connecting the two. Other guests contributed their own carefully chosen messages of love in fabric marker or glitter, while Beth's parents clipped a small branch from the tree under which Craig proposed to their daughter and sewed it on, then embroidered a message and a flower underneath it. Beth and Craig designed the middle square themselves, using translucent fabrics to create an oversized replica of their wedding invitation.

The result was a colorful masterpiece. Just as important, the decorated fabric was a visual expression of love for the betrothed couple. "All the messages were very personal, which is exactly what we wanted," Beth says. "The fact that these loving thoughts were part of the chuppah—creating a physical symbol of how all these people support our marriage—made it even more special for Craig and me."

At Winterthur, Craig and Beth got married outside on the

veranda overlooking the estate's storied garden. It rained for a good half hour immediately before the ceremony, then miraculously cleared just as the service was to begin—which seemed to add an extra lushness to the foliage. The canopy was unfurled and hung, and the couple stepped beneath it to be married. "It felt," says Beth, "as if all the people who contributed to the canopy were standing under there with us. To be surrounded by a little piece of each of the most important people in our lives was priceless."

Cocktails on the veranda followed. Then the guests made their way into the ultra-elegant dining room, which is lined with windows that look out over the grounds of the estate, to dine on a fabulous meal. "Then we danced the night away," says Beth. "By the way, we had a rockin' band!"

Today, the canopy, now with rings removed and filler added, resides in Craig and Beth's new home—"A great memory," says Beth, "of all the special people who were there with us on that unforgettable day."

BETH AND CRAIG'S MOST MEMORABLE MOMENT: *"Our last dance together—because it had been such a long time leading up to our wedding, and we'd put so much into it. We felt so happy to finally be married and have everybody there, supporting us."*

Designing Your Own Chuppah

The chuppah—the ornamental canopy that the bride, groom, rabbi, and cantor (and sometimes the couple's parents and attendants) stand under during a Jewish wedding ceremony—is considered a symbol of the home the couple will make together once they're married. In ancient days, the chuppah was actually a tent, used by the newly betrothed twosome to consummate the marriage immediately following the ceremony (Talk about not wasting any time!). The covering over the couple's heads symbolizes God's presence, while the open sides symbolize the fact that their home will always be open to family, friends, and others, and the four poles holding up the canopy represent the foundation of trust and faith that the marriage rests on.

When it comes to constructing a chuppah, the rules tend to be flexible: Generally the only requirement is that it be big enough to cover the couple and the rabbi marrying them (a square measuring five to six feet on each side is fairly typical). The canopy and the four poles that support it can be made of virtually any material and decorated in any way the couple wants, and the structure itself can range from a solid edifice that can be reused again and again, to a gossamer framework that lasts only as long as the ceremony itself.

Many synagogues and other popular wedding sites own their own sturdily built chuppah that they will lend out to couples getting married under their roof. Chuppahs can also be purchased or rented from florists and other vendors. These days, however, more and more couples are following Beth and Craig's example and choosing to create their own chuppah. Not only does this bring a nice personal touch to the ceremony, but afterward the canopy becomes a priceless keepsake that can be used as a bedspread, bed canopy, or wall hanging.

If you're interested in going this route, you have a number of options:

✳ You can go to an artist or wedding accessory store specializing in custom-made chuppahs. Some vendors have a number of prefabricated artist-created canopy designs to choose from, while others create a canopy from scratch according to your specifications, using paint, silkscreen, appliqués, embroidery, dye, and other techniques—typically with stunningly beautiful results. To find a vendor in your area, do an Internet search using the word *chuppah*.

✳ You can use a quilt, wall hanging, tablecloth, or other piece of fabric that has sentimental value. For example,

some couples have used an antique tapestry or table-cloth that's been in their family for years, while others have used a family tallit, or prayer shawl, as their chuppah canopy. If no one piece of fabric is large enough to serve the purpose, you can stitch two or more such pieces together—or have a seamstress do it for you. For a more finished look, some people also choose to sew a narrow fringe of hemmed fabric to the outside edges of the cloth.

✳ You can buy a new length of cloth and either use it as is, or go on to decorate it. Silk and cotton are two popular fabrics. Light-colored cotton works especially well if you're planning to paint or draw your own designs on it. Some couples choose to invite family and friends over for a group decorating party, during which everyone draws or paints something, or sews a colorful piece of fabric onto the cloth. Having everyone sign the chuppah cloth with a waterproof marking pen is another popular twist. You can also ask family members and friends to contribute pieces of scarves, lace, or other swatches of clothing and fabric that have sentimental value, and sew these onto the fabric yourself.

✳ Finally, some couples decide to make the canopy out of something other than cloth—such as ribbons strung or woven together, garlands of flowers, or vines. (In fact, the word *chuppah* refers to a covering of garlands.) Ribbons can be done yourself—simply tie a series of attractive ribbons side by side, running from right to left across the canopy frame, then tie another set of ribbons side by side along the front of the canopy frame and weave them through the first series before tying them to the back of the frame. The ribbons can be of a single color or of various hues. To make a woven canopy of flowers or vines, your best bet is to consult with a local florist or landscape artist regarding the best materials to use. It may even make sense to hire them to build the structure as well.

Whatever method you choose, the four corners of the canopy will need to have either rings or ties sewed onto them so the canopy can be attached to the four poles that will support it during the ceremony. The poles themselves can be anything from bamboo stalks or branches from some other type of tree, such as birch or cedar, to wooden dowels or posts purchased at a home supply store, to handcrafted wood. Another option is to

bring your canopy to a florist or other vendor who can supply the poles and attach the canopy to them. Some vendors will also rent out chuppah frames that a canopy can be attached to.

The poles should be long enough (generally seven to nine feet) so that everyone can stand under the canopy easily, and have hooks attached at the top to which the canopy corners can be affixed. Some couples also decorate the poles with ribbons, flowers, or vines. To stabilize the chuppah, the bottoms of the poles can be placed into some sort of stable base, such as a flower pot or bucket filled with sand, dirt, gravel, or cement. The bases used to secure outdoor patio umbrellas can also serve. Another option is to add horizontal wooden supports at the top and bottom of the chuppah. If the ceremony is held outside, a pair of light ropes can be attached to the top of each pole and then staked into the ground. Finally, if you have four close friends or family members who are intrepid and durable enough, you could ask them to each hold one of the poles for you during the ceremony—a responsibility that is considered a high honor.

Enlisting the Help of Family and Friends

If you decide to ask your friends and relatives to contribute to your chuppah design, keep the following tips in mind:

* *Be realistic.* Ask only those who you know will be willing and able to take on this extra task. In Beth and Craig's case, they asked only their close family members and attendants to design squares of cloth.

* *Be organized and clear* as to exactly what you want people to do. Beth and Craig sent each person a package, complete with detailed instructions and a square of cloth, then gave people ample time—four months—to complete their designs.

* *Be appreciative.* Let people know in person and also in a note how happy you are with their contributions, and how grateful you are to them for helping to make your wedding so special.

One final note: Before finalizing your chuppah plans, be sure to discuss them with your rabbi, since some congregations do have certain parameters for what a chuppah can and can't include.

THE ULTIMATE "DO-IT-YOURSELFER"

*e*mily and Dave aren't your average twosome, and they wanted a wedding that would shout this to the rooftops. "We're an unlikely couple in some ways," says Emily. "I started my wedding planning with one concept in mind: creating a unique and meaningful event that would be an expression of our tastes and personalities. I wanted a ritual that would embrace our different religious backgrounds, a beautiful setting with the possibility of an outdoor ceremony, and a reception that focused on allowing our families and friends to truly get to know each other. Oh yes—and all of this had to be achieved on a tiny budget!"

This was no small challenge, considering they were planning a catered affair for well over 100 guests—and given that

the *average* cost for a wedding in the U.S. is now approaching a cool thirty thousand dollars. Fortunately, the couple had plenty of creative juices to draw on. Both Emily and Dave work in the radio business, which is how they met: Because of a format change, Emily's job at her old radio station had been eliminated. When she went back to the station in the wee hours to make an audition tape, the only other person in the facility was an employee of the station's rock-and-roll program who was working the midnight to six AM shift.

"I'd gotten a flat tire on the way there," Emily recalls, "and I saw this really handsome young guy with long, curly rock-and-roll hair. He was very concerned with my tire, and went out and helped me change it. He was definitely too young for me, I thought—but still, I was really taken with him."

A few weeks later, Emily found an excuse to show up again at the station late at night. As she puts it, "I managed to keep the friendship going, and we ended up going out for coffee. It turns out he felt the same chemistry I did . . . the rest is history!"

Despite their different backgrounds—Emily is Jewish, while Dave, nine years her junior, is Catholic—they were very much on the same wavelength. When it came time to get married, they dove headfirst into the challenge of fashioning a wedding that embodied their aesthetic sense and their love of life.

For a start, they decided they would have a Sunday after-

noon brunch reception. "This meant a lower price at whatever venue we chose, as well as a party that would be more relaxed and centered on good conversation than a nighttime wedding," notes Emily.

The next step was to find a location. They started looking about six months prior to their October wedding date—in Emily's words, "a short time frame to work with, but doable"—and eventually found the perfect site. "There's a nearby estate in Radnor, Pennsylvania, called The Willows, that a friend of mine knew about," she says. "We went to see it and really clicked with the place. I'd always dreamed of an outdoor wedding, but I didn't want to risk being devastated because it ended up raining on our wedding day. The Willows is a big, historic house set on fifty acres of lawns and gardens, so we could make use of both the indoor and outdoor facilities. It's also really private—you can't see another building—so we had the sense of being in our own little world without having to drive way out into the countryside. And the surroundings were so beautiful, with all the plantings, that there was no need to embellish much at all." What finally sealed the deal, says Emily, was the fact that The Willows allowed the use of outside caterers, which gave the couple control over the food and drink expenses.

Once they'd settled on their locale, everything else started to fall into place. "It was a major first step," notes Emily,

"because it established an aesthetic for the whole event—sort of a country-home vibe—that helped us make all our other selections."

Emily and Dave now threw themselves into manufacturing their own printed materials, beginning with their "Save the Date" cards: On the front of the cards, they used an amusing photo they'd found of a radio announcer from the 1930s standing in front of an old-fashioned microphone. Next to the picture, they printed a headline that read THIS JUST IN . . . EMILY & DAVE SET THE DATE!

"Our guests said that with that card, they knew right from the start that our wedding would be indicative of who we were," says Emily.

The couple also decided to make their own invitations. To find a model for the invitations, Emily embarked on a field trip: "I went with my sketchbook to a really upscale wedding store and leafed through their sample books looking at all sorts of elaborate invitations," says Emily. "Whenever I saw something I really liked, I made a sketch of it."

She took her sketches back home, where she and Dave picked out a design that they felt they could replicate fairly easily. Then Emily got busy. "First, I needed some handmade paper," she said. "I found an art store in downtown Philadelphia that had an entire room filled with samples of different types of

paper, down to details like, what kind of petal infusion did I want?—that sort of thing. I decided on some letter-sized white card stock with an embossed white scroll pattern, which I had cut in half to make five-and-a-half- by four-and-a-half-inch rectangles. I wanted to be sure the invitations would be able to fit into a six-by-nine-inch envelope, since you have to pay extra postage for anything larger than that!"

Next, she purchased some thick handmade paper, "sort of a buttercream color with a nubby finish," soaked it in water, and then, while the paper was still damp, carefully tore it to size against a ruler to create a torn-edged look. The buttercream rectangle, cut slightly smaller than the card stock backing to create a framing effect, was then attached to the card stock with a glue stick. On top of that, Emily again used the glue stick to attach a sheet of clear vellum paper purchased from a local craft store, on which she'd printed the invitation text using her computer's laser printer. Finally, she punched two holes in the top, ran a beautiful, sheer, sparkly ribbon through the holes and tied the ribbon into a bow, giving the appearance that the ribbon was holding the three sheets together.

"It took a little experimentation to get everything right, which is why you should always buy extra materials," says Emily. "But the result was magnificent. Some brilliant designer came up with that three-layers idea—I just copied it."

The couple also used a laser printer to print their response cards, and bought some high-quality rag envelopes to send the invitations in. The total cost for making nearly one hundred stunning invitations—which could easily have cost a thousand dollars or more if purchased from a printer? A little over one hundred dollars.

"The beautiful and lively papers that we used set the tone for everything else that followed," says Emily. "We really enjoyed creating a wedding that was truly 'us' from the very beginning."

In a triumph of on-line shopping, Emily saved another chunk of money by purchasing her wedding dress for $200 on eBay. "I started looking for a dress on the Internet, because I really didn't relish the idea of going to a bridal salon and being poked at and given a million dresses to try on," she says. "I've gone with friends to help them look at gowns and, frankly, I've found it can be very traumatic. So I went on eBay and bought a new dress from a dealer. Its original asking price was $1,500—the tag was still on—but for some reason no one had bought it. I could tell from the listed measurements that it would work, although it would probably need a few alterations. Luckily, the dress had a modified train, which I didn't want, since I knew I'd be walking around on grass lawns. So I had a seamstress remove the train and use the fabric to make the necessary small changes." (Note:

If it had emerged that there was a major problem with the dress, most regular sellers on eBay have a return policy of some sort.)

Emily went back on-line to buy a veil and a tiara—"Boy, did I look at a lot of *those* on-line!" she laughs—and dresses for the younger girls in her wedding party. "I didn't want to burden my friends with being taffeta-clad attendants, but I did want bridesmaids," she says. "My two dearest friends were maid and matron of honor. After that, I took a page from Princess Diana's wedding and invited friends' children and younger cousins to be in the wedding party. I ordered the little girls' adorable lavender dresses for forty dollars each from a children's formal wear dealer on eBay."

Next on the couple's to-do list was to make the table toppers. "The tables were going to have plain pink tablecloths that went to the floor, which are quite inexpensive to rent," she says. "The table toppers are what kill you, costwise, so I set to work. First, I went to some stores to see what the professionals were doing. Frankly, it was all pretty bland stuff. We knew we wanted something really colorful, so I went to a big fabric outlet and got a great price on a whole bolt of cloth in very rich colors—mauve and rose and soft green."

It took only four hours—two hours of cutting with pinking shears, and another two spent sewing the two halves of each topper together—to create fifteen eye-catching table coverings.

"When people walked into the dining room at our wedding, the impact of those colors was dazzling," says Emily. "We didn't need any fancy floral arrangements, because the fabric did the job for you. So we paid a small sum to a florist to arrange some white snapdragons on each table. The effect was simple and elegant, like something you'd pick out of a country garden and pop into a vase." With the addition of the floral chuppah in the garden, two more arrangements, one for the sign-in table and another for the ladies' room, and a few potted mums wrapped in fabric left over from the table toppers, the stage was set. The couple also tapped their circle of talented friends for other services that they couldn't have afforded otherwise. One friend gave the personal flowers for the ceremony as a gift. Another friend, a skilled photographer, offered to take pictures of the event as his wedding gift to them.

Two other friends supplied the music. "Since I work in radio, I asked one radio friend, who has exquisite, very sophisticated taste in music, and another who has a home studio to create the music for the celebration," says Emily. "They recorded two hours of great dance music for the reception. And for the cocktail hour preceding the meal, they put together a mix of carefully selected love songs—all of them little gems that a lot of people hadn't heard before. The cocktail-hour songs were dubbed onto a CD titled 'Greatest Love Songs of Dave &

Emily's Wedding,' which we gave to guests as a wedding favor. The cover was designed by an artist friend, with our picture on the front and the song titles and artists' names on the back."

To save on the cost of the food—typically one of the biggest expenses in hosting a reception—the couple hired "the most reasonable highly rated caterer we could find" to serve a brunch buffet. "This is one area where I don't think you want to go homemade," says Emily. "Our caterer had been written up in *Philadelphia* magazine, so he was obviously talented, but he wasn't that well-established yet and had never worked at this venue, so he was willing to give us a good price. We also provided some extras ourselves that would have been expensive if they'd been supplied by the caterer, such as chocolate truffles, the wedding cake, and additional gourmet desserts."

The weather on Emily and Dave's wedding day turned out to be ideal—a warm, clear fall afternoon, with the Pennsylvania foliage just starting to take on its autumn coloring. The ceremony was conducted in tandem by a rabbi and a Catholic priest. "The traditional Jewish and Catholic services have many elements that are similar," says Emily. "Both of the clergymen stood side by side and went through the ritual together. They were friends and had done this before. We had readings from the New and Old Testaments, and some people read poetry as well. What was really beautiful was having them explain the

meaning of each tradition, which doesn't happen at your typical wedding. The rabbi explained the breaking of glass, and the drinking of the wine, and the seven blessings, while the priest explained the various scriptural readings."

What Emily remembers most about the ceremony was a wonderful feeling of acceptance. "This idea that the two of us, two people with vastly different backgrounds, could find a place where these traditions merge—could come together and find love, which is so central to both religions, was incredibly moving," she says. Finally, as a special touch, each guest was handed a rose quartz crystal—a stone that has symbolized a connection of the heart dating back to the days of ancient Rome, when it was given as a gift of love—and asked to hold it tightly while thinking their fondest wishes and hopes for the couple.

The reception that followed lived up to Emily's original concept perfectly. While the food and dancing were inside, people could also walk out into the garden and the surrounding grounds, chatting and enjoying the music of a harp player on the lawn. "It was like a big party in someone's home, everyone moving around this big house from room to room, or wandering outside," she says. "What made it truly wonderful was the conversation. I really wanted our families and friends to have a chance to meet one another, and relax and talk together. A lot of very interesting connections got made that day. One of our

guests, a Catholic priest who had left his parish to get married, was even able to help a couple of other guests reconnect with their faith by telling them about some nontraditional congregations where they would feel accepted."

In the end, they pulled off the wedding of the year at a cost of just $9,000, at a time when the price tag for the average American wedding was over twice that. And today, Emily and Dave's "homemade" wedding remains the gift that keeps on giving. "A number of friends tell us that they always put on our love-song CD whenever they're hosting a party," says Emily. "I've also used several of the table toppers to make tablecloths for my mother and my mother-in-law. They love that—to be able to pull out a little piece of our wedding and serve dinner on it!"

As for the bowl of rose quartz crystals, the couple keeps it on a special shelf in a curio cabinet, next to some wedding pictures. "It's a wonderful reminder," says Emily, "of all of our loving family members and friends, and the shiny hopes that were wished for us that day."

EMILY AND DAVE'S MOST MEMORABLE MOMENT: *"At the end of the ceremony, when the rabbi and the priest blessed the marriage and the gathering. Both of them raised their hands and spread their fingers toward everyone sitting there.*

Then the rabbi read the blessing in Hebrew, and the priest repeated it in English. People were very touched by that. It was the moment when the two faiths overlapped completely."

Do It Yourself—Without Doing Yourself In

Creating certain aspects of your wedding yourself—or drawing on the creative talents of friends or relatives—is a great way to add a personal touch to the celebration, and can also be a real money-saver. If you're thinking of undertaking a few do-it-yourself projects for your nuptials, however, it's essential to plan them out carefully, leaving yourself plenty of time to get them finished before the big day, and also to avoid biting off more than you can chew. After all, the most important thing you bring to your wedding is your own happiness and welcoming spirit. Spending the week before your wedding stressing out over unfinished tasks wouldn't be fair to your guests, your future spouse, *or* yourself.

In general, the best approach is to start as early as possible and focus on doing only those things that you are good at and truly enjoy doing. The same holds true when it comes to enlisting the help of friends and family members. If you're considering going the do-it-yourself route, you'll also need to find a way

to let people know you're open to contributions without putting anyone on the spot. A good way to do this is to be candid about your needs without making any specific requests of people. If someone is able and willing to help, this should be enough to prompt them to volunteer.

Some exceptions to this approach would be when you're asking someone to do a reading or make a musical contribution to the marriage service, or participate in the ceremony in some other way. In these cases, it's perfectly appropriate to ask friends and relatives directly.

Often, friends will offer their services as a wedding gift to the couple—especially if they are professionals at what you're looking for, or their particular contribution (even if amateur) involves a significant amount of time and effort, such as doing the photography or assembling a music playlist. If the friend doesn't state explicitly that their work is their gift, you can help by making it clear that you consider their assistance to be their gift to you: "I can't thank you enough for offering to arrange all the floral centerpieces. We couldn't have asked for a better wedding gift—your arrangements are going to make the reception!" You should also offer to pay for any supplies that might be needed.

Following is a brief list of do-it-yourself possibilities to

consider when planning your own wedding. (See also, "De-signing Your Own Chuppah," page 45.)

Flowers

Buying flowers from a local wholesaler and arranging them yourself can save you hundreds—if not thousands—of dollars, but it will also require time and careful preparation. The first step is to decide what flowers you want, which will depend on both your color scheme and budget (you can help keep costs down by selecting whatever is in season). Bridal magazines, wedding Web sites, and floral shops are all good sources of in-spiration. Just check carefully with your wholesaler to be sure the flowers you've chosen will be available on the date of your wedding. (Hint: Many wholesalers will state they sell only to retail stores, but they're usually willing to make an exception when it comes to a bulk sale for a private wedding.)

Once you have an idea of what you want your centerpieces and bouquets to look like, buy a small selection of flowers a few weeks or months before the wedding and practice arranging them. You should also buy all ancillary materials—such as vases, bows and ribbons, floral tape, floral foam, and a "strip-per" (a tool to remove thorns, if you plan to buy roses with thorns still on) well ahead of time.

For the wedding itself, you'll need to have an ironclad

delivery date for your flowers—typically one or two days before the wedding. Be aware, too, that many businesses will only deliver on business days. You'll also need a cool place to store the flowers as soon as they arrive, such as a small room with its own air-conditioning unit, which should then be run full blast (just don't let the cool air blow directly on the flowers). You'll also need to have a number of buckets filled with room-temperature water, in which the flowers should be placed immediately.

Finally, when arranging the flowers on the eve or the morning of the wedding, set aside a specific work area and enlist the help of several friends to speed up the process.

A tip on corsages and boutonnieres: Giving these to your mothers, fathers, and other close relatives to wear at the wedding is always a nice touch, but if you're making them yourself, there's no need to get too elaborate: A single flower affixed to a lapel pin will do just fine for a boutonniere; and for a corsage, simply substitute a larger pin and add a ribbon and a sprig of baby's breath.

Party favors

Party favors are certainly optional. But if you really want to give them, and are operating on a budget, they are also one of the easiest wedding items to make yourself—as long as you

keep things *simple*. Here are some classic do-it-yourself favors. (Hint: For an extra touch, add personalized tags bearing the name of each guest.)

Sachets. These small bags of fragrance are always welcome, since they bring a wonderful scent to closets and drawers for months and years to come. Cut out circles of mesh netting, lace, or other porous cloth, then fill with potpourri, cinnamon sticks, lavender buds, rose petals, nutmeg cloves, vanilla beans, dried orange peels, or another aromatic material of your choice, often available at stores that sell spices and herbal products. Tie closed with a length of yarn, ribbon, string, or leather strip, leaving several inches at both ends so the sachet can be tied to a hook or closet rod if desired.

Goodie bags and tins. Cut out a circle of attractive cloth, fill with chocolate-covered nuts, nonpareils, kisses, mints, truffles, homemade cookies, or other favorite sweets, then tie shut with an ornamental ribbon or string. Or put the goodies in a lidded tin container and tie a ribbon around it.

Homemade preserves. Just wrap the jar in tissue or, easier still, tie a ribbon or string around the jar.

A favorite poem. An inspirational way to commemorate your special day. Print out the poem—along with the couple's name and wedding date—on parchment scrolls, then roll them up and tie with a ribbon or string.

Soaps. A selection of three or more bars of different hand-made scented soaps, wrapped in tissue or placed in an ornamental bag, will be enjoyed long after the wedding.

Mini champagne bottles. Buy them in bulk, then simply add a decorative ribbon and name tag to each bottle. Even better, include a scroll of paper containing a favorite poem or saying (see above).

Invitations and Other Printed Materials

Designing your own wedding invitations, save-the-date cards, wedding programs, and thank-you cards can save you hundreds of dollars, and in this age of personal computers it's never been easier to do. All you need is a good printer, attractive fonts, and some high-quality paper to print on—and, of course, time and attention to detail. To get ideas for invitation and save-the-date designs, check out wedding invitation Web sites or visit stationery stores that specialize in wedding materials. A number of retail and on-line stationers now sell blank invitations, cards, and program pages that you can simply put into your printer, typically at a cost of about one dollar per invitation, and less for other items. It may be even less expensive to buy larger sheets of card stock and cut them to size yourself. Top-quality envelopes and tissue paper can be purchased from the same sources.

Wedding-ceremony programs can usually be made using

standard eight-and-a-half-by-eleven-inch sheets, using letter stock for the inner pages and card stock for the front and back covers. Once the printed material is ready, take the pages to a local copy or print shop to have an inexpensive binding put in.

A somewhat pricier option—but still much cheaper than ordering invitations from a printer—is to bring your own invitation design in electronic form to an offset printer, along with your own card stock, and have them do the actual printing. This gives you the option of using raised type, and will generally yield a better-quality printed product no matter what sort of type you choose.

Accessories

Table toppers, the bridal veil, the small pillow that the rings are carried on—all of these can be made yourself by following directions available on do-it-yourself wedding Web sites, if you're skilled at sewing. An easier route is to buy the raw materials and take them to a seamstress or tailor. This will cost more than making them yourself, but will still be much cheaper than buying these items readymade in a store.

Music

Uploading a raft of songs onto an iPod in preselected order, then hooking up the device to speakers and letting 'er rip, has be-

come a favorite and oh-so-easy way to manufacture your own ceremony and reception music. If you don't want to hunt for processional music or the perfect first-dance tune, some Web sites now offer entire "sets" of wedding ceremony and reception music that can be downloaded onto your home computer for just a few dollars. If you prefer, you can also transfer your playlist onto a CD for playing over a stereo system, either by using your own CD burner or by paying a modest sum to a local audio shop to do it for you. This has the added advantage of turning your wedding music into a permanent keepsake recording—plus you can always make duplicate copies for friends and family.

If you want your wedding playlist to be a little more spontaneous, ask a friend or relative to monitor the iPod and select tunes as the mood (or guests' requests) dictate. For a relatively small fee, there are also companies that will set you up in business as your own DJ—renting you the equipment and the musical selections, and giving you a quick lesson in how to spin your own tunes all night long.

Food

Most experts agree that the food for the reception is one area that is probably best left to a professional, since preparing and serving a number of courses is the last thing you want to be dealing with on your wedding day. If cost is an issue, you may

be better off simply having a wedding at a nonmeal time of day (such as midafternoon), and providing only hors d'oeuvres.

On the other hand, having friends and relatives pitch in by bringing various dishes can be a viable alternative—and a huge money saver—provided people are ready and willing to do so. Some communities even have a tradition of potluck wedding receptions. If you do take this approach, try to have someone else coordinate who's bringing what. One contribution to the menu that a skilled friend or relative often will offer as a gift is to make the wedding cake. If so, it may be a good idea to ask them to do a test cake on a smaller scale, so there aren't any surprises on your wedding day.

A COMMUNITY CELEBRATION

*W*eddings are always about more than simply two individuals getting married—but for Hope and Andrew, getting married was truly a group event. They met and fell in love while attending an Episcopal seminary in Evanston, Illinois, where both were studying to be ministers. In their midtwenties, they were among the youngest students in the divinity school, and had been more or less adopted by their older classmates. When they decided to get married, the couple felt very strongly that their marriage should be a celebration not only of their own union but also of the spiritual community that had been the center of their lives for the past two years.

"Like God's love that lavishly spills out into the world,"

explains Andrew, "the love between spouses ought to extend out as hospitality, charity, and love to the larger world."

They both agreed that the wedding service would be the most important part of the day—and so they invested the bulk of their energy in shaping a ceremony that would truly embrace and reflect the religious community and beliefs that were so central to their life together. "The very first decision after we got engaged had to do with what vestments all the clergypeople would wear at the ceremony!" chuckles Hope. "Our seminary has beautiful vestments that were designed to evoke nature and creation—with bright blues and greens to represent water, and reds, oranges, and yellows representing the sun."

It was also clear "right off the bat," says Hope, that they would get married in the seminary chapel, a Gothic mini-cathedral in the heart of the campus, designed to resemble an old English cathedral. "We could never have picked one hometown over the other—and for two years we had been worshiping several times a day in the chapel. To get married anywhere other than this place we loved so much wouldn't have made sense. It was a part of who we were as a couple."

The couple knew that one of their biggest challenges would be to find a way to accommodate the extraordinary number of clergy who would be involved in the ceremony. The Episcopal

bishop had cleared his schedule so that he could attend and lead the service. ("It meant a lot that he came," says Hope. "He had to skip a diocese meeting to make our wedding.") In addition, there were a number of other friends and mentors from the seminary and the diocese who Hope and Andrew wanted to play a part in the ceremony.

While staying within the rubrics of the Episcopal prayer book's marriage rite, the couple carefully tailored the liturgy to involve as many of their colleagues as possible. "We had every order of minister participating: lay, deacon, priest, and bishop," recalls Andrew. For help in planning the service, Hope and Andrew consulted with a professor of liturgy at the seminary. "She's married to another clergyperson, just like Andrew and me, and their marriage has a wonderful strength to it," says Hope. "In fact, they're sort of role models for us."

The couple started working with their friend and advisor very early in the process, carefully going over every aspect of the service: The music, the readings, the sermon, the marriage vows, the blessing of the rings, the prayers for the couple, and the blessing of the marriage.

They all agreed that their advisor would preside over the actual wedding ceremony, administering their wedding vows and blessing the rings herself. The other rituals were carefully parceled out. "We had one good friend preach the sermon,"

says Hope. "Two other friends—one who was in seminary with us, another from out of town—did readings, while two other clergy, who had attended seminary with us, sang a duet accompanied by the organ. For the part of the wedding service that involves prayers for the couple, we chose a beautiful piece about how when we hurt each other, we can find ways to forgive each other. Then we had our mothers read it together, alternating the petitions between them."

Following the prayers, the bishop blessed the marriage, the couple kissed, the congregation exchanged the peace, and then the ceremony segued into a communion service led by the bishop. The gospel was chanted by the deacon, who was assisting the bishop. "It was a passage from John, saying, 'no one has greater love than this, to lay down his life for a friend,'" says Hope. "It reflected how we both thought about marriage—that a wedding service can be seen as the laying down of your own individual life, and picking up a new life together."

Other friends and family served as lector, acolytes, and ushers. The ceremony reached its emotional peak when Andrew's father, a professional trumpet player, played a soaring solo. "The whole service was extra-meaningful because we had personal relationships with everyone who was involved," says Andrew.

"I was so emotional through it all," adds Hope. "I wanted to laugh and cry at the same time."

<p align="center">✳</p>

The service concluded, the guests passed through a receiving line in the hallway just outside the church, then stepped outdoors straight into the seminary garden, known as the West Garth, where friends had set up an English tea amid an enchanted world of green lawns and flowering bushes, bordered on each side by ancient trees, green hedges, and carved-stone buildings—complete with gargoyles.

It was a gorgeous September afternoon, just two weeks after Hurricane Katrina had devastated the Gulf Coast, which added a heavy dose of emotion to the day. Andrew and his family were from New Orleans, as were many of their invited guests. "After making sure my parents could make it, we decided to go ahead with the wedding as planned," says Andrew. "So many of my hometown friends, who were scattered by the storm, told me that the wedding was such a wonderful time for them. It was a little bit of normalcy in the chaos of their displaced lives—a happy occasion in the middle of a difficult period. It was also a reunion of sorts, since it was the first time some of them had seen each other since the storm."

Though they were on a student budget, Hope and Andrew

and their friends had created an atmosphere of almost magical elegance. The couple hired a reasonably priced and creative caterer—a friend of a friend—who provided two servers and a fabulous English-themed fare for the tea celebration, all for under $5,000 (when the average price of a wedding was over $25,000). On two exquisitely arranged serving tables, three varieties of tea sandwiches were arrayed: Prosciutto and figs, strawberries and cream cheese, and cucumber and watercress.

The tables were covered with fine damask linen, set off by the bright pink, blue, and green napkins that Hope had picked out to match the gerbera daisies used as decoration throughout the reception. Silver trays offered a choice of vegetable crudités or a medley of strawberries, watermelon morsels, and grapes. There were also miniature quiches, plus authentic English scones and Devonshire crème.

"We found glasses and champagne flutes, as well as classic—and classy!—white cups and saucers, to rent for a really low price," says Hope. "It was amazing how beautiful this inexpensive china looked, sparkling in the sunshine. Our caterer also provided elegant silver teaspoons and serving pieces, and we had rented china for the finger foods and cake."

For the tea service itself, guests were offered either tea or coffee by the two tuxedo-clad servers who poured from exqui-

site silver tea and coffee urns. As everyone entered the West Garth, they were also handed a glass of either champagne or sparkling water. During the celebration, drink choices included fruit punch, sparkling water, and juices. The bride and groom also planned carefully for their guests' comfort, borrowing some tables and chairs from the seminary so that people could sit wherever they chose. For those who craved recreation, there was even a croquet green in the adjacent quadrangle.

One of the couple's favorite menu items appeared toward the end of the party. Instead of having a traditional wedding cake, they served stacks of colorful cupcakes—known in England as fairy cakes. The caterer made these in three different flavors: Chocolate, vanilla, and strawberry, with bright icing that matched the gerbera daisies and the napkins.

"The cupcakes were much less expensive than a wedding cake would have been," explains Andrew. "Plus they were delicious! And we didn't have to wait for the caterer to cut cake slices for everyone. Our guests really seemed to enjoy helping themselves from the colorful stack."

Friends put up decorations and set up equipment for music and speeches. A close family friend made the bride's gown and her maid of honor's sea green satin dress, as well as the groom's and ushers' ties, which were crafted out of the same green fabric. Another friend, an amateur florist, bought the

flowers for the ceremony and the reception for wholesale at the Chicago flower market (total cost: $200) and arranged the flowers for free as her wedding gift. The arrangements were placed on the serving tables, and the backdrop of the university's gardens rounded out the scene.

A friend on the seminary staff, a professional photographer, took photos throughout the ceremony and reception—her own wedding gift for the couple—while the background music came from the speakers hooked up to the groom's iPod. (In preparation for the day, Andrew and his best man created a playlist of the couple's favorite songs.)

"The whole community really had an active hand in celebrating our wedding with us," says Andrew. "In more ways than we can list, our family, friends, and mentors contributed their energies and creativity to a wonderful event. We truly felt buoyed up by the love and support of everyone who was there with us."

HOPE AND ANDREW'S MOST MEMORABLE MOMENT: *"Taking communion together for the first time as husband and wife. Since communion was such a central part of the spiritual tradition we were both studying to become a part of, this was truly an important and special moment for us."*

Planning Your Wedding Vows

For all the effort that goes into planning your wedding recep-
tion and the various festivities that go with it, it's important to
remember that the marriage ceremony itself is the real reason
behind the celebration. And nothing is more central to this
ceremony than your wedding vows. Not only do they repre-
sent the very start of your marriage, but they're also a public
statement of your commitment to each other—a commitment
which, in turn, will form the foundation of your life together.

"To love and honor" . . . "As long as we both shall live" . . .
"For richer for poorer." Phrases like these are more than just
poetic expressions of love; they signify, to the two of you and to
everyone witnessing your vows, that you are going into your
marriage with the realistic knowledge that your relationship is
something that will be constantly changing over time, and that
you promise to work together as a team to keep your relation-
ship healthy, vital, and strong.

As important as all wedding vows are, the actual vows that
couples make to each other can differ tremendously, running
the gamut from traditional vows that must be recited verbatim
to completely free-form statements that the bride and groom
write themselves. Some couples have even been known to wing

it, simply telling each other whatever pops into their heads at the moment.

To find out what your options are, you'll need to talk to whoever is officiating at your wedding. Your degree of flexibility is likely to vary, depending on whether you're getting married by a clergyperson, or by someone unaffiliated with any formal religion, or by a justice of the peace or other civil servant. If you're getting married by a member of the clergy, you'll need to determine what religious tenets, if any, have to be included in your vows. Similarly, if you're planning a civil ceremony, you'll need to find out if there are any legal requirements regarding your vows. It's also true that flexibility can vary a great deal within specific religions. A more orthodox clergyperson may insist that you follow the traditional wedding service to the letter, while another from the same faith may be perfectly glad to let you modify the traditional vows, or even throw them out and write your own from scratch.

Fortunately, even the most conservative clergy and civil servants are usually willing to make at least slight changes to meet the wishes of the bride and groom. One very common example of this is the stipulation—still found in many traditional wedding services—that the woman agree to "obey" the man she is marrying. A great many women have, quite un-

derstandably, objected to including this word. And from what we gather, most officiants have been happy to oblige them.

Here are some tips on how to shape your wedding vows in ways that work for you.

✳ If you have the option of reciting either traditional vows or vows of your own choosing, decide together whether you'll use the vows offered by your clergyperson, create your own, or go with an adaptation of the traditional religious vows. Whichever way you go, make sure the words are ones that reflect your personalities, and that both you and your betrothed are comfortable with.

✳ Whether you go with traditional vows or compose your own, review together the commitments you plan to make in your vows and be sure you both agree on them and find them personally meaningful. This means discussing and double-checking your values with each other, to be sure they're in synch. Is there any aspect of the commitments that one or both of you would like to change? If so, bring this up with your officiant at the earliest possible moment.

❋ When going the nontraditional route, you can research Web sites and books for inspirational writings and poems, or you might choose to write your own vows. If you're writing your own, allow plenty of time to create, fine tune, and review them.

❋ When composing your own vows, try to keep them "short and sweet." Brief and beautiful is far better than long and drawn-out.

❋ When reciting your own vows, prepare thoroughly. Try to complete them well ahead of time, then practice saying them. Also, give a written copy to your clergyperson to have on hand at the ceremony, just in case. If you're trying to memorize the words, keep a backup version on note cards with you that you can read from in a pinch.

❋ As romantic as it might sound, it's never a good idea to spring any surprises on your mate or the officiant regarding the vows you plan to use. Make sure you run your vows by each other and the person performing the ceremony *before* the big day.

❋ If the two of you are from different faiths or cultures, vows that honor each other's backgrounds are especially meaningful.

Some Sample Wedding Vows

✳ In the name of God, I, [name], take you, [name], to be my wife/husband, to have and to hold from this day forward, for better for worse, for richer for poorer, in sickness and in health, to love and to cherish, until we are parted by death. This is my solemn vow. *(Episcopal Book of Common Prayer)*

✳ I, [name], take you [name], to be my wife/husband, to be the mother/father of my children, to be the companion of my heart, to have and to hold, from this day forward, for better or for worse, for richer for poorer, in sickness and in health, to love and to cherish with my whole heart, and with my complete devotion, I pledge you my love. *(No source)*

✳ I, [name], take you [name], to be my wife/husband; and promise before God and these witnesses, to be your loving husband/wife; in plenty and in want; in joy and in sorrow; in sickness and in health; as long as we both shall live. *(Book of Common Worship)*

✳ I, [name], give myself to you to be your wife/husband. I promise to love and sustain you in the covenant

of marriage, from this day forward, in sickness and in health, in plenty and in want, in joy and in sorrow, as long as we both shall live. (*Book of Worship, United Church of Christ*)

✳ I, [name], accept you [name], to be my wife/husband, friend, companion, and lover. As we continue our lives together, I will strive to grow in understanding, in tolerance, and in acceptance of change. I promise to love you in conflict and cooperation, in pleasure and pain, in joy and in sorrow, for who you are and who you will become, both now and forever. (*No source*)

✳ I [name], I promise not to question your needs. I promise to seek your peace. I promise to put your happiness first. For it is in giving that I receive. And it is in helping you awake that I awake. [Name], I love you. I bless you. I want to walk home to God with you. (*A Book for Couples* by Hugh Prather and Gayle Prather; Doubleday 1988.)

PART THREE

*tradition with
a twist*

MARRYING THE WHOLE FAMILY

*W*hen Kimberly got engaged to Rodger, she didn't have to worry about introducing him to her two daughters from her previous marriage. In fact, they befriended "Uncle Rodger" well before she did.

"Rodger is actually the brother of my sister's husband," explains Kimberly. "When the girls were little, my sister used to babysit them. Frequently she would take them over to her then-boyfriend Daryl's house, where Daryl's brother Rodger was also living. So they'd known Rodger for at least a year before he and I ever met."

Kimberly and Rodger finally connected at a party, over a spilled drink—"I apologized and toweled him off"—and began dating three months later. After going out for a couple of years,

they took the next step and got engaged. "We'd been talking about it for quite a while," says Kimberly. "I had moved into a new house with a yard that needed a lot of work. Rodger and I and the girls had spent quite a bit of time pulling up weeds, planting flowers and trees, and putting in a sandbox. A short time later, when the girls were away, Rodger—who is really very romantic—called me outside at sunset and went down on one knee. I thought he'd dropped something, so I leaned over to help him look, and we knocked our heads together! After we recovered, he said to me, 'Look what we've built together. Will you be my wife, so we can continue building beautiful things together?'"

By this time, they were already a family unit in all but the official sense. "When we started dating, I let Rodger know right away that I'm a package deal—love me, love my children," says Kimberly. "During the time we dated, we did lots of stuff together just like a family—going to the beach, camping trips, that sort of thing. Rodger was over for dinner almost every night. He did everything but live with us."

When the time came for the couple to get married, it was a given that Kimberly's two girls, Melissa, then age seven, and Meghann, age five, would be an integral part of the ceremony. "We talked a lot about how we wanted to include them," says Kimberly. "Rodger wanted the wedding to be very meaningful

to them. The girls were always with us; we did everything to-gether. Now, we were becoming a family, which really meant that they were getting married, too. So how could they not be a part of it?"

They agreed that the girls would be "bridettes," rather than flower girls—"because, after all, a flower girl is only a flower girl," says Kimberly. Rodger's mother made them each a peach-colored dress with ivory lace, using fabric that matched Kimberly's own ankle-length, mermaid-style Victorian wed-ding dress. The bridettes had much to say about the flavor of the wedding cake (chocolate) that Kimberly's mother made. In addition, Rodger purchased two small rings to give to the girls during the wedding ceremony.

The couple had chosen to have the ceremony and reception at the Oak Knoll Naval Officer's Club in Oakland, California. "It's a beautiful place, and the perfect size for our guest list, which was about 225 people," says Kimberly. "My father-in-law was a veteran, which qualified us to use the facility." The cer-emony itself took place outside in the club's central courtyard. With Rodger and his groomsmen waiting up by the altar, Kim-berly's bridesmaids walked down the aisle, followed by Melissa and Meghann walking hand in hand. Then came Kimberly, escorted by her father.

The minister who was officiating went through the marriage

service, concluding with the exchange of vows made by Rodger and Kimberly. At this point, Rodger took out the two small rings, then turned to his two young daughters-to-be and kneeled before them.

"I, Rodger Griffiths," he began, "take you Melissa and you Meghann to be my daughters, to love and honor and cherish so long as I live, and I promise you that I will be the best daddy I can be. I love you." Then he placed the diamond rings on their ring fingers. "Wear these rings proudly," he told them. "It's a symbol of my promise to you."

The minister—who had repeated Rodger's vows to the girls over a microphone, to make sure all the guests could hear them—then pronounced Rodger and Kimberly to be husband and wife, and the four family members walked back down the aisle together.

The reception that followed stretched on through the afternoon, with bride, groom, and bridettes sharing the spotlight. "It was the most fun I've ever had at a wedding!" says Kimberly.

Today, the two girls are in their twenties and have two younger sisters, Michele and Madalyn, born to Kimberly and Rodger after their marriage. "Melissa and Meghann still remember getting their rings, and how proud and grown-up they felt, and how much it made them feel part of their new family,"

says their mother. "Meanwhile, our two younger daughters always ask why they didn't get to get married, too!"

KIMBERLY AND RODGER'S MOST MEMORABLE MOMENT: *"Our first dance with each other and with the girls. We danced alone together for the first quarter of the song. Then, without any prompting, five-year-old Meghann, who must have been feeling a little left out, ran onto the floor, and Rodger picked her up in his arms. It felt like the most natural thing in the world. So we waved to Melissa to join us as well, and the four of us finished the dance together. It was really very sweet. When we looked at the wedding video later, we could see everyone at the wedding dabbing their eyes as they watched us on the dance floor."*

Including Your Children in a Second Wedding

As we've pointed out elsewhere in this book, weddings are not just about the bride and groom. This is especially true when one, or both, of the people getting married has children from a previous marriage. In this case, the feelings of your children must come before those of your parents, or of any other family members or friends. By definition, your decision to remarry affects them in a huge way, since they'll now be part of a new family structure. For this reason, second

marriages tend to be a very emotional, even stressful, time for children—especially younger ones. As consumed as you may be with your wedding plans, this is a time to make a special effort to take your children's feelings into account and provide plenty of support and understanding for how *they* are experiencing your wedding.

Laying the Groundwork

Some of the most important parenting challenges arise well before the wedding itself, at the time when the two of you actually decide you want to get married. Remember, this decision not only means your kids are gaining a new parent but it also extinguishes any hopes they've been harboring—as all kids secretly do—that their original parents might yet reconcile and get back together. Here are some suggestions on how to help the transition go smoothly:

* Inform your children of the engagement before telling anyone else, including your parents—and *especially* before telling your ex-spouse(s).

* Speak with your children alone, without their future stepparent present. This way, the children will feel

more comfortable expressing any concerns and asking questions.

✳ If possible, when you do inform your former spouse (the children's other parent) of your engagement, elicit his or her cooperation in helping the children get used to the idea.

✳ Assure your children of your love for them. Let them know that although your family situation is going to change, they are always going to be a major part of it.

✳ Help your children choose the name they want to call their new stepparent. Many kids choose to call the stepparent by his or her first name, while others opt for "Mom" or "Dad." The goal is to find a name that feels right to the children and the stepparent.

✳ Include your children in some of the time you spend with your fiancé/fiancée, to give them a chance to get to know one another better.

✳ Involve your children in the steps you take toward building a new family, such as showing them a new house you're planning to buy, asking them to

choose their bedrooms, and having them help with moving in.

❋ Be observant of your children: Keep the lines of communication open. Listen. Show them your love and support.

Involving Your Children in the Wedding

One of the best ways to reach out and stay connected with your kids during this period is to give them a chance to be part of the wedding planning and the big day itself—*if* this is something they want to do. Because kids often have mixed feelings about seeing their mother or father marry someone new, experts agree you should leave it up to your children themselves to decide how much they want to be involved in the various aspects of the wedding.

"Some children will want to be very involved," says Beth Ramirez, author of the book *Bride Again*. "Others may be shy about participating, or feel that they're betraying the other parent who's not getting married. If that's the case, then as a parent you should just back off and let it be."

Many children, of course, will be thrilled to be a part of the wedding and everything leading up to it. In this case, the chal-

lenge is to involve them without overburdening them or taking too much time away from normal parent-child activities. A good approach is to ask your children what role *they'd* like to play. To help them out, you might propose a variety of options—also making it clear that it is perfectly okay if they don't want to do anything at all. Often, children who are reluctant to participate at first will change their mind at the last minute and ask to be included in some way. For this reason, we suggest keeping a small role "on tap" for children who have opted out of participating, such as reading a poem or standing beside the couple at the altar, in case they do have a change of heart.

Here are some popular ways for children to participate in a second wedding.

Planning the wedding:

❋ Helping the parent select his or her wedding outfit (a daughter might help her mother choose her bridal gown, for instance)

❋ Picking out their own outfits to wear at the wedding

❋ Helping the couple select family items on their gift registry

❊ Helping the couple choose the flavor of the wedding cake

❊ Selecting the color of flowers to carry and throw while walking down the aisle

❊ Helping to choose certain items on the reception menu, especially if there's going to be a "kid's menu"

❊ Choosing some "must-play" songs for the reception

❊ Reviewing the RSVPs, as they come in

At the ceremony:

❊ Serve as a junior bridesmaid or usher or, for younger children, a flower girl or ring bearer

❊ Do a reading during the service (younger children could read a very short poem)

❊ Hand out ceremony programs to guests as they arrive

❊ Come up to the altar rail during the service to receive a blessing

❊ One thing that is *not* recommended is having a male child escort his mother up the aisle, particularly

if the child is young. It may look "adorable," but in reality it places an unfair emotional burden on the child.

At the reception:

✳ Watch over the signing of the guest book when guests first arrive

✳ Hand out party favors

✳ Join in the first dance partway through

✳ For older children, offer a toast to the bride and groom

The Family Vows Ceremony

Including a "family vows ceremony" as part of the wedding service is an increasingly popular choice at second weddings. This ceremony usually takes place immediately after the couple say their vows to each other. The family vows themselves can take any form you and your children wish. Typically, they involve a statement of love and commitment from one or both parents to the children, and perhaps a

similar sentiment on the part of the children as well. The ceremony may also involve giving rings to the children, as in Kimberly and Rodger's wedding, or some other piece of jewelry, such as a necklace or medallion, bracelet, or earrings—often engraved with the child's initials and the wedding date.

Two other touches, known as the "sand ceremony" and the "unity candle," are also popular additions to a family vows ceremony. In the sand ceremony, which originated in Hawaii, a tall glass vase or other clear container is placed on the altar, and every member of the family is given a vial of sand to hold. The officiant explains that this sand symbolizes all the members of the family—the bride, the groom, and their children. The bride and the groom each pour their vial of sand into the vase in turn, then the children follow suit, one at a time, while the officiant says the following: "As these grains of sand are poured into the unity vase, the individual vials will no longer exist but be joined together as one. Just as these grains of sand can never be separated, so it will be in your marriage and your new family."

The unity candle is a similar concept: A large unity candle is placed on the altar, and each family member is given a small candle to hold. The bride's candle is lighted first, and then

the bride lights the groom's candle, he lights the first child's candle, and so on. All then turn to the big candle and light it together, before blowing out their own candles to symbolize that they are no longer their own individual selves, each with his or her own flame, but one family, united.

LEAP OF FAITH

*f*or Ellen, her marriage to Mazher was the culmination of a personal journey. Although raised a Protestant, she had begun searching for a new spiritual pathway after college. "My first job out of school was working in a home for abused children," she recalls. "It was very difficult emotionally, and I turned to religion to help get me through—only to find that the religion I'd grown up with didn't have the answers I was looking for."

Ellen had known Mazher since her student days; his best friend from high school was a close college friend of Ellen's, and the two of them met one summer when Ellen paid her friend a visit. "Mazher and I became good friends, but since he was Muslim and I was Christian, we never thought of taking

things any further," she says. Later, when Mazher learned of the personal struggle she was going through after college, he sent her several books on Islamic religion to read.

"The books sat on my shelf for two or three months," she recalls. "I was literally scared to open them up, because I had all these stereotypical beliefs about Islam. Finally I read one of the books cover to cover, and discovered that it literally described what I already believed."

When Ellen made the decision to convert to Islam, she says, "Things became easier and more difficult at the same time—easier, because I'd found where I felt I belonged, but more difficult because I had to go through all the cultural aspects of telling my family and other people that I planned to leave Christianity and become a Muslim."

That summer, she spent a good deal of time with Mazher's family. "He and his sisters and his parents answered a lot of my questions, and really helped me through the transition," she says. With the removal of the religious barrier to their relationship, Ellen and Mazher's romance blossomed as well. Ellen officially converted, and three months later the couple became engaged. The wedding was set for the following May.

This gave the bride and groom six months to plan a wedding that would bring together two very different traditions—the Scottish-American culture of Ellen's family,

and the Pakistani-Muslim culture that Mazher had grown up with. The most important priority was to ensure that the marriage ceremony and celebration conform to Islamic principles. Among other things, this meant that the men and women in attendance were not allowed to see each other, following the custom that an adult woman can be viewed unveiled only by the males in her immediate family. Another priority was to plan a wedding which would be enjoyed by their friends and families—even those unfamiliar with Islamic religion and customs.

For Ellen and Mazher, the key challenge was to figure out which traditions were strictly Islamic, and therefore had to be followed to the letter, and which were actually Pakistani ethnic traditions. "We both felt that if a custom was purely cultural, whether it was from Pakistan or from my own Scottish background, then we were at liberty to follow it or not, depending on how we felt," says Ellen.

Mazher's father, who is an imam (an Islamic religious leader), was an invaluable help in this regard. Ellen and Mazher would put their questions to him, and he would then research the answers. The biggest question had to do with Ellen's participation in the marriage ceremony itself.

"Typically at a Pakistani-Muslim wedding, the bride's guardian and the groom stand together before the imam and

affirm the marriage," explains Ellen. "The bride doesn't even necessarily have to be there."

Ellen, on the other hand, wanted to be able to speak for herself during the ceremony, if possible. After hours of careful research, her future father-in-law concluded that nothing in the Koran actually prohibited a bride from giving her own verbal consent during an Islamic marriage ceremony—the custom of the guardian giving consent was a cultural tradition, not a religious one.

Ellen embraced other Pakistani customs enthusiastically, such as taking part in the *mehndi*, the Pakistani version of a bridal shower, in which the bride and her female friends and relatives come together to celebrate the upcoming wedding by, among other things, coloring their hands and feet with henna dye.

"We also wanted to include some touches from my Scottish heritage," Ellen says. "For example, we decided to have a bagpiper accompany my father and me into the ballroom where the ceremony was held. We also agreed that Dad would wear a kilt, and I would wear a sash with our family tartan on it over my wedding dress, which was a simple white wedding gown."

The couple's careful research, planning, and consultation with their respective families paid off in a big way: Not only was the wedding celebration a seamless merging of cultures

but it turned out to be an unforgettably special experience for everyone involved. Here's how Ellen describes it:

"The Nikhah Khutba [marriage sermon/wedding ceremony] took place on a Friday evening. Both the ceremony and the reception were in the same oval-shaped ballroom at my family's local country club in Charlottesville, Virginia. The 150 guests were seated at round tables of eight, with the men and women totally separated by a screen. The women were dressed beautifully in either the traditional Pakistani *shalwar* and *chamise* (long shirt and pants) or American-style dresses, while the men all wore suits. My father and I made quite a dramatic entrance at the start of the ceremony, the bagpiper walking in front of us playing the processional, followed by Dad in his kilt and me in my white head scarf and white gown, topped by a sash with the Buchanan tartan on it."

There were two head tables, also on either side of the screen—one for the men in the wedding party, including Mazher and his and Ellen's fathers, and one for Ellen and the other key women, including her mother and future mother-in-law. As the guests arrived, Ellen's brother told them of the seating arrangements. Non-Muslim women were offered the option of sitting with their male escorts on the men's side, if they so chose. Every woman, without exception, chose to sit on the female side.

The imam who presided over the ceremony read from the Koran, then went on to give a sermon in which he explained the significance of the Koranic verses he'd just read, as well as the philosophy behind keeping the sexes separated. He then asked the bride and groom if they consented to the marriage. From their respective sides of the screen, both replied, "I do."

With Ellen and Mazher now officially married, the wedding celebration began. The food was a classic American-style buffet, though without any pork products. There was no alcohol served and no dancing—but plenty of socializing. Following Pakistani custom, Ellen sat on a couch on her side of the room, and the female guests came over one by one to chat with her. Meanwhile, guests of both genders, each on their own side of the screen, were busy getting to know each other.

"Our guests kept telling us later how thoroughly they enjoyed the good mix that was created," says Ellen. "People had lots of opportunity to talk with one another and learn about their respective religions and cultures. One American woman guest told me, 'Normally, my husband is very quiet and barely talks at parties. Here, he found himself actively participating in fascinating conversations with his tablemates.'"

For all their adherence to Islamic ritual, Ellen and Mazher were also able to put their own unique spin on the occasion. "My entrance was a lot more formal than in a typical Muslim

wedding, where the bride just walks in casually with her family," says Ellen. "Also, Muslim brides are traditionally rather shy and reserved at the Nikhah, since it's often a time when they're leaving their family to live with their groom's family, which can be a little sad. I wasn't really interested in conveying that feeling—I was *very* upbeat and happy about the whole day."

Another departure occurred in the celebration's last couple of hours, which is customarily a time when most of the guests have departed, leaving just the close family members, who then take down the dividing screen between the sexes and mingle freely. "We decided to open this period to close friends as well," explains Ellen, "using the reasoning that they were, in fact, family."

Two days later, again following Islamic custom, a second wedding reception was hosted by Mazher's family in the groom's hometown of Baltimore. The seating arrangement was similar to that of the Nikhah. This time, however, guests were served Indo-Pakistani food, and Ellen wore a traditional Pakistani wedding gown of red embroidered material as she received her guests. "I looked quite different from the way I did at the Nikhah!" she smiles. Again, the event went off smoothly for everyone involved.

Ellen reports that she and Mazher continue to hear com-

ments from people about how educational and uplifting their wedding celebration was. "We were worried that some people might consider certain aspects of our wedding un-Islamic, but we kept getting feedback from everyone about how appropriate everything was," she says. "Nine years later, we're still reliving the warm feelings that enveloped us that weekend."

ELLEN AND MAZHER'S MOST MEMORABLE MO-MENT: *"Walking down the hallway to the sound of bagpipes, then getting to the ballroom and seeing all the men on one side and all the women on the other side, half of them wearing gorgeous Pakistani outfits, and the other half wearing gorgeous Western dresses. It was wonderful to see that meeting of the cultures, different but intermixed, right there in front of us."*

Sharing Cultures and Traditions

Any wedding is, in a sense, a merger of cultures, since it brings together two different families, each with its own customs, attitudes, and backgrounds. But when the two people getting married come from very different cultures, integrating the traditions and customs of these cultures to create a seamless celebration is often the biggest challenge in planning the wedding. After all, every culture has its own special ways of

celebrating and honoring the joining of two people in marriage, many of which have been carefully passed on for many generations. When deciding as a couple which traditions to include in your wedding and how to include them, it's imperative that you plan thoroughly and respectfully—taking into account not only your own feelings but also the feelings of your families and of your wedding guests in general.

Deciding What Traditions to Include

As with any aspect of the wedding planning, the process should begin with the two of you: Take some time as a couple to discuss your values and expectations—religious, ethnic, and familial—as well as what specific traditions each of you would like to include in the ceremony and reception. If you want to have an interfaith ceremony, for example, now is the time to bring this up. It's likely that you'll also want to seek out information and viewpoints from your families and officiants before you make any final decisions. Before you do this, however, it's essential that you make sure you're both on the same page.

The next step is to ask both sets of parents for their input regarding wedding traditions they think are essential, or at least worth considering for inclusion. In some cases it may be better for each of you to have these discussions with your par-

ents *without* your fiancé/fiancée present, to allow your parents to feel more comfortable about delving into their backgrounds with you. In other cases, the discussion could be richer and more productive—and also more of a bonding experience for everyone involved—if both of you are present during the interview. Every couple's situation is different, so follow whatever approach seems best for your particular circumstances. You may also wish to interview other relatives, especially senior ones, who could have insights to share. Conducting on-line research or referring to books that explain your family's cultural and religious traditions could also prove helpful.

As you explore these issues, you may decide there are certain family traditions that, for one reason or another, you don't want to include. In that case, you'll need to explain to your parents and other family members as early in the process as possible that, while you value and respect the tradition in question, you simply don't feel that it fits with your particular wedding plans.

With some cultural traditions, you may first need to determine whether they're a religious element or a secular custom. In Ellen and Mazher's case, their key challenge was to figure out which traditions were strictly Islamic and therefore had to be followed to the letter, and which were actually Pakistani—or, on Ellen's side, Scottish—ethnic traditions that they could

choose to follow or not, depending on how they and their families felt about them.

If you're planning to have a religious ceremony, it's especially important to ask your clergyperson—or clergypersons, if you're planning a ceremony that combines two different religions—right up front about any religious traditions that absolutely must be included in either the ceremony or the reception (such as the requirement at Ellen and Mazher's wedding that the sexes be seated separately) as well as any prohibitions on what cultural aspects are allowed within that religious service. Typically, there are wide variations in what different religions, and even different clergypersons within the same religion, deem acceptable. One minister we spoke with actively encourages couples to include rituals from their pasts. He was delighted, for example, to have a couple jump the broom—signifying the crossing of a symbolic threshold into a new life together—at the end of their interracial Protestant wedding service that he presided over.

Making Your Guests Feel Comfortable

Once you've decided what traditions from your respective cultures will be included in your wedding, you'll need to consider ways you can help your wedding guests feel as comfortable as

possible with any customs that are unfamiliar to them. Anyone you're inviting to your wedding almost certainly knows at least something about your respective family backgrounds. Still, if you're incorporating any customs that are relatively uncommon, a number of your guests could well be experiencing something new.

One important way you can help ensure your guests' comfort is to inform them ahead of time about what to expect and, if necessary, how to dress and/or prepare for the celebrations. This should start with your initial contact with guests: Whether this is a save-the-date notice or the actual invitation to the wedding, include enough information to give your guests a general idea of what's going to occur. For example, a line on the invitation indicating that "Ellen and Mazher are planning an Islamic wedding ceremony" gave guests a basic sense of what would be taking place. Then supplement this with a note, either in the invitations or in a separate mailing, providing guests with basic information about what to expect—including any clothing restrictions and a timetable for the ceremony and reception. If you like, you can include your and/or your parents' phone numbers and offer to provide further details and answer any questions verbally. If you have a wedding Web site, guests can be directed there for further information as well.

If there are some cultural restrictions or expectations

regarding wedding gifts, this is best handled by word of mouth. As with any wedding, a more delicate verbal approach is far better where gifts are concerned than including a written directive about registries along with the invitation. Similarly, if a guest is unsure about what kind of gift is acceptable, he or she should ask someone close to the couple.

At the wedding itself, it's always helpful to provide guests with a program outlining the order and components of the wedding ceremony. Many couples include detailed, written explanations of their cultural heritages and religious customs—input that guests are sure to appreciate.

Other information can be passed along verbally, as well. During the reception, for example, guests could be encouraged to share their knowledge of particular foods and customs with other guests. In addition, the officiant, the couple, or one of their family members or friends might give a short talk about the couple's cultural or religious customs, as the imam did at Ellen and Mazher's wedding. At the interracial marriage where the couple jumped the broom, the father of the bride stepped up into the pulpit and delighted the congregation with his rendition of the story behind the custom of jumping the broom.

*

The bottom line: When the challenge of merging cultural traditions is handled with consideration, communication, and creativity, the result can be a thrilling and even transcendent experience—forging a powerful bond that will continue to resonate in the lives of the couple and their families forever after.

A TRAVELING RECEPTION

*l*ike many couples, Ann and Henry got to know each other through another twosome—in this case, Taiga and Ed, their respective pet dogs. "Henry lived about a mile away from me in the same downtown area of Waterbury, Vermont," says Ann. "I'd already met him at some neighborhood events. He had a very distinctive car, an old red Volvo, and I used to see him driving around town. At one point, Taiga, my lovely female husky, went into heat, and this old mongrel came by and sat beneath my window for a week, howling. Finally I asked a mutual friend, 'Isn't that Henry's dog?' So I called Henry, and he came by and got Ed. The next day, Taiga disappeared. Having a pretty good idea where she'd gone, I drove over to Henry's—and there she was."

After chatting awhile, Ann told Henry that she'd seen him driving around and asked if he'd be interested in carpooling to work to save on gas. A couple of other friends joined the carpool as well, and for the next six months the four of them shared a car to work and back. By that time, their friendship had turned into something more, and the two of them began dating. Eventually they decided to move in together, and shared a home for a year.

"Since we were already living together, getting married was a natural step," says Ann. "We'd been talking about having children, and for that to happen it made much more sense from a legal standpoint to become husband and wife. We also felt we wanted to affirm our commitment to each other for the rest of our lives. But at the same time, it wasn't like most people were asking themselves, 'When are they going to tie the knot?'—although I do think my parents might have been wondering that!"

Once they'd decided to get married, the next question was *how* to do it. Henry wasn't enthused about the idea of a full wedding celebration, since it would have been virtually impossible for his parents to attend—his father was in a nursing home and couldn't travel at all, and his elderly mother lived a day's drive away—while Ann, who'd been married once before, had no interest in a big wedding either. After talking it over, they

came up with a simple solution: They wouldn't have a wedding at all. Instead, they would elope and tell everyone about it afterward.

"It wasn't a very difficult decision," says Ann. "It was simply what we wanted to do. It's the way we've always lived our lives together. We never know what we're doing next week!"

At that time, the state of Vermont required couples to wait at least three weeks after getting their marriage license before getting married. Ann and Henry got their license in late June, and since Ann's birthday is July 22, they picked that date as their wedding day. They agreed to keep their plans to themselves. "In Vermont, you don't need any witnesses to get married," Ann says, "so we decided this would just be between us. It was kind of fun having this secret that no one knew."

Their wedding day was a Thursday. They both went to work that morning, then met at lunchtime at city hall in the neighboring city of Burlington. "We showed up at the office of the city clerk, whose name was Frank, and asked him if he could marry us. He said 'Sure,' as long as we had all the paperwork, which we did. I think he was a little surprised at that—I don't imagine too many people come in to get married with all their documents already in hand—and he asked if we could give him ten minutes to prepare."

Ann and Henry then went to the park adjoining city hall

and sat for a few minutes, savoring the moment. "It was a nice, quiet interlude on a beautiful summer day," Ann remembers. "At last we went back in, and Frank took us upstairs into a meeting room with a big, heavy table and chairs. It was just the three of us. We went through the standard minimal vows—the only thing we dropped was the bit about 'obeying'—and just like that, we were married! Originally we'd both planned to go back to work afterward, but we decided that was silly. So we went and got some lunch instead."

As they walked out of the Burlington city hall, the couple began pondering who they should break the news to first. "It's a little like developing the guest list for a wedding reception," Ann says. "You don't want to hurt anyone's feelings, so it's important to think through who you'll tell and how you'll do it. We started with our immediate families, because a marriage is really a union between two families. We wanted to let the people who were part of that union know as soon as possible."

Henry and Ann immediately thought of Henry's father, who was in the nursing home outside of Albany, and was always the last to learn of any news. A visit really wasn't possible, so right after lunch they called him before notifying anyone else. Next, they called Henry's mother and told her. "It was very important to us that we informed Henry's father first,

followed by his mother," says Ann. "This time they were the first to hear the big news. Naturally, they were thrilled!"

Since it was Ann's birthday, the couple had already made plans to visit her parents in the late afternoon for a celebratory drink, and that's where they headed next.

"At the time my parents owned some hayfields, and when we arrived there, my father was out on his tractor mowing hay," Ann recalls. "We stood around for a bit, chatting with my mother, until finally I couldn't stand it anymore. 'Do you know what we did for my birthday?' I blurted out to my mother. 'We went to Burlington and got married!' Her jaw dropped to the ground. It was a great moment—it's not often you can render my mom speechless." Eventually Ann's father finished mowing. "He came in, cleaned up, and then settled down with us for that drink. This time it was my mom who could hardly contain herself. 'Well,' she said, 'aren't you going to tell him what you did for your birthday?'" Now it was her dad's turn to be struck speechless. "The four of us shared a toast, and grinned till our mouths hurt," laughs Ann.

They spent the next hour celebrating the news, then the couple headed on to the home of Henry's brother Bert and his girlfriend, who lived just down the road. Their pet cat had just had kittens, and Henry and Ann were escorted into the bedroom to see the new litter. As Henry came out of the room, he

casually asked if they could use the phone. "We need to call Ann's brother and tell him we just got married," he announced. Once Bert and his girlfriend had recovered from their surprise, they showered the newlyweds with embraces, kisses, and congratulations. Then they brought out some beers to toast the marriage and demanded to hear the whole story from the beginning.

From there Ann and Henry returned to their house to call their other siblings and a friend or two from work, before driving to the house of another close friend. And so it went. "We just arrived at the homes of family and friends and told the people there we had just been married," says Ann. "Everywhere there were hugs, kisses, congratulations, and toasts. It was so special to see the looks on everyone's faces."

Their traveling reception had been completely unplanned, but for Henry and Ann it turned out to be the perfect way to celebrate their marriage. "Years later, we still look back on that day with joy and affection," she says. "It could not have been more special. The whole day has as much meaning for me as if we'd had a big party. One of the best parts was that we were able to spend quality time with everyone we visited. In particular, I remember the joy we felt, and that the people around us felt on hearing the news. Marriage isn't just a joining together of two people but also two families—and even though

Henry and I eloped, our wedding was very much a family celebration. It shows that a wedding isn't about a party, it's about the event."

Ten years after they married, Henry's parents passed away. On their fifteenth anniversary, Henry and Ann had a church service in which they took the wedding rings that had belonged to Henry's mother and father, had them blessed, and placed them on their own fingers. "Henry's parents had a long, committed, special relationship," says Ann. "It means a lot to us to wear their rings, especially since they were the first to hear our own special news."

ANN AND HENRY'S MOST MEMORABLE MOMENT: *"Letting our parents know that we'd joined our two families together. We still drive by the place that we called Henry's dad from, and say 'That's where it happened.' And we still remember the look on the face of Ann's mom when she first heard the news."*

How to Elope—Gracefully

There's something romantic—even thrilling—about the idea of an elopement. Maybe it's Hollywood's doing: Who can resist those films where the hero and heroine fall in love and, on the

spur of the moment, decide to run off into the sunset together and live happily ever after?

Eloping in the movies is one thing. In real life, however, our recommendation to any couple who might be contemplating this option is that you do some serious soul-searching before you decide to elope. For starters, both members of the couple need to be in *absolute, complete agreement* that this is how they want to get married. If the bride doesn't really want to elope, but the groom is all for it—or vice versa—then going through with the elopement is certain to create resentment, which is hardly the way you want to begin your marriage.

If both partners jump at the idea of heading to city hall and "just doing it," as Ann and Henry did, then you're home free. Another common scenario involves one partner floating the idea of an elopement. In this scenario, the person doing the floating needs to carefully assess his partner's expectations and desires regarding the kind of wedding she wants. It may be that she doesn't want to spend too much money on a wedding; or perhaps she's been married before and would prefer a low-key wedding this time, in which case the thought of elopement could be appealing. On the other hand, if she's always dreamed of a full-blown wedding, this dream has to be respected and deferred to. If one person raises the idea of eloping and his or her partner balks at the concept, don't force the

idea. Instead, look for a possible compromise by exploring alternatives that might work for both of you. A small, simple wedding, for instance, might be the perfect way to go.

Another important factor to consider is how your parents will feel about your elopement. The parents, on either side, might have always dreamed of attending your wedding, and they could well be upset and disappointed about being deprived of the opportunity. If you think this might be the case, but you and your partner are still convinced that eloping is what you want to do, then you'll need to work at convincing them that elopement is best for you. Rather than springing your marriage on them after the fact, a better approach is to gently ease them into the idea *before* you actually elope: "We just can't imagine having a big wedding," or, "We're actually contemplating eloping." That way, you can assess their reaction. If they're positive and empathetic to your situation, then you're in luck. If they're upset, give them some time to get used to the idea. Once you've eloped and they see that you're both happy in the long run, it's very likely they'll come around. Even if they never quite get used to the idea, however, ultimately it's your marriage: Only the two of you can decide what's best for you, given your situation.

Sharing the News

When telling people about an elopement, you'll need to draw on your diplomatic skills to ensure that no one's feelings are hurt. Some elopements are total surprises; others are a semi-surprise, in which a few people close to the couple serve as witnesses and/or provide moral support. In either case, a lot of people will be learning about your marriage for the first time—and you'll want to make sure the people closest to you hear the news from *you*, and not from someone else.

Start by making a list, as a couple, of who you'll share your news with and in what order. Tell your parents first, and decide which order you'll tell them in. There's actually an exception to the statement we just made: If there are children from any previous marriages, they should be told even before your parents.

After parents and any children of the couple are informed, share the news with immediate family members: Siblings and grandparents, then other relatives. Give thought to the order here, too: Perhaps it makes sense to tell grandparents first, or to inform siblings in birth order. Each situation will be different. Finally, fill in your friends in the most logical way, starting with those closest to you. At the workplace, it is usually best to inform your boss or supervisor first, followed by close

coworkers or those who work most directly with the bride or groom. Again, every couple's situation will be different; the key is to think through your plan for sharing your news ahead of time. If you do, you're certain to make considerate choices.

Try to pass along your news in person whenever possible, especially when informing those closest to you—this will give everyone a chance to fully share the emotions of the moment. A phone call, handwritten note, or personal e-mail are also acceptable ways to spread the word. (Avoid a mass e-mail, which is too impersonal for such important news.)

What do you say to people? That's easy! Everyone will see how happy you are, and that eloping was the right choice for you. If you like, you can refer to the circumstances that prompted your decision—for example, that you're saving money for a house, or felt it was too complicated to plan a wedding with families scattered in many locations. At the same time, be sensitive about not offending those people who had traditional weddings by disparaging those weddings or saying that your way is better.

To inform a wider range of less-intimate friends and acquaintances, you might choose to print and send out a traditional announcement, or even design one of your own. Such announcements can be issued by the parents or by the couple themselves. Send the announcements out as soon as you can

following your elopement—even as early as the day after. Some couples also announce their elopements in their local newspapers.

Another way to tell others about your elopement is by sharing photos or a video of the event. Some elopements occur during a trip taken by the couple to a particular (sometimes faraway) destination. Take photos or some video footage, and have the images ready to show upon your return. Another thoughtful touch: Give a photo album of your destination wedding to each set of parents. They'll treasure it forever!

Celebrating an Elopement

The way people celebrate an elopement can vary greatly. Often, family, friends, and coworkers will want to do something for the couple. A party is one way to go. It can be hosted by the couple themselves, the bride's parents, the groom's parents, or any other family members, close friends, or coworkers. The party—basically, a belated wedding reception—is usually less elaborate that a regular wedding reception would be. That said, it can be as fancy or casual as the hosts and the couple want.

The timing of an elopement party is also variable: It can occur days, weeks, or even months after the elopement. It can

also take the form of a series of spontaneous celebrations, as in Ann and Henry's case. Still another way to celebrate an elopement is to have a religious ceremony to bless the union at a later time. Many couples choose to do this on an anniversary of their marriage, but it can be done anytime a couple chooses.

Regarding the matter of gifts: Elopement gifts are not obligatory, but close relatives and friends will usually want to send them anyway. Many eloping couples even announce that they don't want any gifts, but they nonetheless do receive them. Only in a case of a party for which the invitation reads "no gifts please" does the friend or relative need to heed the request and forego the present (if they still want to give the couple something, doing so either before or after the party is fine). The bottom line: Gifts for a couple who have eloped are optional. The couple may still register as a way of helping people who do want to give gifts make their selections (in fact, it's a good idea to do so). And, of course, handwritten thank-you notes are a must for these gifts—just as with any wedding gift.

PART FOUR

the perfect setting

THE WEDDING FEAST

*K*arin and Justin got married on the same vineyard where they'd first gotten to know each other as young children—a 100-acre spread in California's Sonoma Valley that Justin's father had owned and developed, and where Karin's father, then a recent émigré from Sweden, had taken the position of foreman as a young man, bringing his wife and four children along.

"I've known Justin my whole life. He's five years younger than I am, which is a huge difference when you're little kids," says Karin. "But then we met again after college and . . . well, I always knew I wanted to fall in love with a farmer!"

When they became a couple, the two of them took up residence in the vineyard and began to concentrate on restoring its

production of wine and related products. "Our first vintage came out in 2007, around the same time as our wedding," says Karin. "We also make verjus, a semiripe grape juice that can be used in place of, or in combination with, vinegar. And we're beginning to experiment with saba, a grape syrup that you make by taking very ripe grapes and cooking them in a big copper pot for six to eight days."

With their intimate knowledge of food and wine, Karin and Justin wanted the fare at their wedding to be more than good: They wanted a feast to remember—one that began early and lasted until the last guest had departed, with a diverse menu that celebrated the fertile countryside they and their friends call home.

"We wanted foods that were very conducive to harvest time," says Karin. "Our wedding was in late July, the middle of summer, and we wanted items that were growing naturally out in the garden. We also wanted to incorporate our own verjus and saba sauce into some of the dishes. It was especially important to us that we had foods that would go well with our wine. Our first vintage, released under the label Garden Creek Vineyards, is a Bordeaux-style red wine, a blend of Cabernet Sauvignon, merlot, and cabernet franc grapes. It's a very hearty wine, full of tannins, so its flavor goes well with stronger cheeses, grilled meats, and other robust foods."

To make their vision a reality, they turned to Carrie Brown, owner of the nearby Jimtown Store—a gourmet food shop known to foodies far beyond Sonoma—and a caterer extraordinaire. "I'd known Carrie for years," says Karin. "She sold our verjus in her store, and I used to call her all the time for business advice. Asking her to cater our wedding was the most natural thing in the world. I also trust her taste completely. We didn't do any tastings ahead of time—I knew that whatever she came up with would be fantastic."

With her instructions in hand, Carrie and her chef, Amy, set about developing an eclectic menu that would be served in stages, carrying the wedding revelers from the five-thirty cocktail reception straight through the evening into the postmidnight hours.

When the eighty-plus guests arrived for the four o'clock ceremony, they parked in another part of the vineyard, then walked to the base of a rise known as the Olive Hill, where the ceremony would take place. "It's a very beautiful spot, surrounded by three old olive trees, with a great view of the surrounding countryside," says Karin. "You feel humbled, somehow, when you stand up there."

After everyone had gathered, they walked up the slope in procession. To quench everyone's thirst, a table with ice water and fresh lemonade was waiting at the top of the hill. Then

Karin and her father followed, walking up slowly together. "Everybody had formed a circle, with our immediate family in the innermost row," Karin recalls. "I walked into the center of the circle, where Justin was waiting." There, standing on a carpet of rose petals, they were joined together as husband and wife.

The wedding celebration then moved down the hill to Justin's father's house, where the reception would take place. A number of platters were set out, each containing romaine leaves and summer vegetables arrayed like a giant flower around a bowl of Jimtown's own green goddess dressing. "I always like having one stationary hors d'oeuvres that people can munch on while waiting for the passed hors d'oeuvres to get to them," Carrie explains. Meanwhile, waiters moved among the guests with trays of grilled scallops topped by Karin and Justin's saba sauce and served on freshly picked rosemary skewers, mini crab cakes with remoulade sauce, and Moroccan spiced lamb served on a baguette with harissa sauce. As a nice touch, the grills used to broil the scallops and the lamb and to warm the crab cakes were placed close to the serving area, giving guests the chance to savor the aroma of the cooking food.

"Our challenge was to create a sort of cultural melting pot," says Carrie. "There were going to be some Swedish elements, and to complement this we brought in a sort of Medi-

terranean theme. Sometimes when you take a melting-pot approach, it can dilute the overall menu. The way to avoid this is to have foods with amazing flavor that can stand on their own while also blending together nicely. That's why I like to pair all my protein dishes with a distinctive sauce."

At seven o'clock, the guests sat down at their tables—where they found a menu at each place setting—and the first entrée was served. It was a traditional Swedish dish, in honor of the couple's shared heritage: Like Karin's parents, Justin's mother had also been born in Sweden. The course began with a Swedish song, sung by Karin's father. Then the guests toasted the couple with a shot of aquavit, followed quickly by pickled herring and boiled red potatoes with sour cream. "The aquavit and herring is a great way to get the party going," says Karin.

"I love the idea of having a toast early in the event, to bring everyone together," adds Carrie. "This was almost like a blessing of the food. You can always have more toasts later. But too often, at weddings, people wait until quite late before gathering everyone for the toast."

To accompany the food, Justin and Karin had bottles of their own wine plus a number of fine reds and whites produced by friends at neighboring vineyards. When it came to naming the tables where the guests ate, however, they took a different tack. "We named all the tables after jug wines, like Carlo Rossi

and Thunderbird," Karin laughs. "We thought this was more fun than naming them after serious varietal wines—it was sort of an inside joke among us wine people." The names were printed on large sheets of paper in an old-fashioned serif type-face. The edges of the paper were then burned slightly, and big black nails were used to fasten each sign to a pair of old red-wood grape stakes. "It was a really nice look," adds Karin.

Following the herring and potatoes, the rest of the main courses were laid out buffet-style, with servers manning two full buffet tables so that two tables of guests could go up and be served at a time.

"The salmon and steak came right off the grill," explains Carrie, "but the other foods were served at room temperature and, since it was summertime, we didn't have to worry about keeping them warm. That gave us a little more flexibility. Again, every dish was designed to stand on its own but also blend very well with the others."

A variety of artisanal breads were also arrayed on the ta-bles, along with spiced olives and a dipping sauce of olive oil and black pepper. "The breads with olive oil alone were ter-rific, but eating this along with the olives and peppers provides a special taste experience," says Carrie. "It went just a little above and beyond."

It was already a feast to write home about—but the food

didn't stop there. "Justin and I really wanted the food to keep flowing through the night, so that people kept nibbling while they were dancing and drinking," says Karin. And so, following dinner, Carrie and company set out a table filled with a variety of cheeses, spiced nuts and dried dates, as well as bowls of fresh berries and whipped cream, decaf coffee, lemonade, and a number of different teas. "I especially remember the big jug of hibiscus tea," Karin smiles. "It was *so* good!"

"The board was literally groaning with food," Carrie recalls. "There were all sorts of textures. Food was strewn everywhere. I had bundles of herbs strung between the cutting boards and wire baskets filled with crostini, which is sliced bread covered with olive oil and a sprinkling of sea salt, then lightly toasted. It looked like some fabulous eighteenth-century Spanish still life—a feast for the eye as well as the palate!"

As night fell, while the wedding guests danced to a jazz-blues band, Justin lit a huge fire pit that he'd dug for the occasion and filled with twenty logs. The flames shot into the air, lighting up the whole party. "The fire pit was just another touch—a nice, warm place for people to hang out," says Karin. "We really wanted a communal celebration, where everyone felt like they could stick around and enjoy themselves."

Eventually the wedding cake was brought out. It was a

traditional Swedish marzipan princess cake, made by a local Swedish bakery.

The celebration finally ended sometime after midnight, but the memories linger on. "People are still raving about the food," Karin admits. "They tell us, 'Great wedding—and *great* food!' It was a beautiful night. When you're surrounded by the love of your friends, it's just a wonderful thing."

KARIN AND JUSTIN'S MOST MEMORABLE MOMENT: *"I remember walking with my father up the vine row of Cabernet Sauvignon wine grapes toward the ceremony on the Olive Hill, slowly without music—just the peace of the afternoon and the hot sun on our backs—cherishing each moment before I would stand next to my beloved Justin, from this moment forward as husband and wife. My eyes met with Justin's when we reached the grove of olive trees. My father gave Justin the handshake of a lifetime and presented his daughter to him. I couldn't take my eyes off of my husband-to-be, and we held hands from this moment on throughout the entire ceremony, feeling our love and happiness, knowing that this was the greatest and most important decision and moment in our lives."*

The Menu

Iced Lemonade and Water Table set up
at the site of the ceremony at 3:45 PM

Passed Appetizers

Grilled Scallops on Rosemary Skewers

with Terra Sonoma Saba

Mini Crab Cakes

with Remoulade Sauce

Moroccan Spiced Lamb Loin

with Harissa on Baguette

Stationary Appetizer

Summer Vegetables with
Hearts of Romaine "Flower"

with Jimtown Green Goddess Dressing

Plated Traditional Swedish Wedding Toast

Pickled Herring, Boiled Red Potatoes, Sour Cream and Chives
Served with Aquavit Shots

Main Course Buffet

Miso-Glazed Loch Duart Salmon Skewers

with Lemongrass–Tamarind Dipping Sauce

Long Grain Rice Pilaf

with Sweet & Sour Onions, Pine Nuts and Chives

Grilled Bavette Steak
with Italian Salsa Verde

Israeli Couscous and Rainbow Pepper Salad
Soft Herbs and Young Lettuces Salad
with Verjus Vinaigrette

On the Tables

Artisan Bread Basket
(Country Walnut, Cranberry Semolina, Foccacia)
with Extra-Virgin Olive Oil–Black Pepper Dipping Sauce
& Spiced Olives

After Supper

Jimtown Cheese Table
St. George, Manchego, Aged Gouda, Gorgonzola
with Spiced Nuts, Baguettes, and Crostini

Bowls of Fresh Berries
with Freshly Whipped Cream

Dessert

Princess Wedding Cake—Plated and Served

Beverages

Decaf Coffee & Tea (Herbal & Black Tea)
Sparkling Hibiscus Tea and Lemonade

Wine List
..

Garden Creek 2002 Tesserae Red Wine—a Bordeaux blend
(from our family winery)
Hippolyte Reverdy 2005 Sancerre
Preston 2006 Dry Creek Sauvignon Blanc
Preston 2006 Dry Creek Viognier
Quivira 2005 Dry Creek Fig Tree Vineyard Sauvignon Blanc
Quivira 2005 Grenache
J 2002 Vintage Brut

Taking Your Wedding Menu to the Next Level

Among other things, weddings offer a great opportunity for friends and family to join together in a communal feast. Whatever food you serve your guests, whether a multiple-course dinner or simply hors d'oeuvres and wedding cake, it will help set the tone for every other aspect of your wedding celebration. Many couples turn to a professional caterer or restaurant chef to arrange and execute their wedding menu, while others choose to rely on the contributions of family and friends. Whoever's doing the cooking, however, by putting some careful thought into what you're serving and how it's served, you can take the food at your wedding to the next level.

Choosing a Caterer

The first step in deciding who you want to cater your wedding is to start thinking as a couple about the experience you want to give your guests, as well as what you can realistically afford to spend. How big a wedding are you planning? Do you envision passed hors d'oeuvres and a sit-down plated meal, or stationary hors d'oeuvres followed by a family-style dinner or a buffet? All of these factors will affect the cost significantly.

When interviewing caterers, start by asking for a ballpark estimate of their per-person cost—including food, staff, and any goods that have to be rented—over the phone *before* you sit down to meet them for the first time. This approach will save everyone's time by helping you steer away from caterers who are out of your price range.

When you do sit down with the caterer, be prepared to talk about the style of meal you want—do you envision something resembling a restaurant meal in terms of food, presentation, and service, or a more personal approach, as if you were entertaining your friends and family at home, only with fabulous help?

You should also be willing to discuss the atmosphere you want to create for yourselves and your guests. As Carrie says, "You eat with your eyes." Talk to the caterer about the colors you envision on people's plates and how this will interact with

the colors of the flowers, table settings, even the clothes worn by the wedding party and other guests.

When making your final decision on who to hire, keep in mind that this is a very personal relationship. You need to trust that this person can create an event that will reflect who you are as a couple. Ask yourself: Do I feel a rapport with this person? Does he or she understand the feeling I'm hoping to create? In addition, ask to see a copy of the caterer's contract before signing on the dotted line, and look for extras that might be charged in addition to the food and staff—such as overtime or garbage removal—and whether the gratuities for the staff are included or discretionary. That way you won't have any unpleasant surprises.

Planning the Menu

Unless you have been to other dinners or events catered by the company you're hiring, and feel you know their food so well that you can simply "talk through" the details of the menu, you're going to want to arrange a tasting session where you can sit down and sample a variety of the caterer's dishes. The tasting should be held several months in advance of the wedding, and the tasting menu should be as similar in style as possible to the food offerings you have in mind.

During the tasting, concentrate both on the food and on visualizing your wedding day and the dining experience you want your guests to have as you bond with friends and family around the table. The goal is to make your wedding memorable in every detail—and food is an important emotional component of this festive day. Remember, you'll be celebrating the first supper of your married life!

Caterer Carrie Brown says the ideal wedding menu must have *harmony*. "When deciding what to serve your guests, you want to be looking for distinctive, flavorful dishes that can stand on their own," she says, "but you also want them to work nicely in context with each other." To accomplish this, consider serving a variety of dishes within each food group. You might offer a seafood dish and two different meat or fowl dishes along with a salad as appetizers, for example, then serve a different type of meat, fowl, or seafood for the main course, complemented with two different types of cooked grains and an array of vegetable and fruit dishes.

You're also probably better off striving for overall balance in your menu than trying to adhere to a single ethnic or cultural theme. In preparing the specific dishes you plan to serve, the best results will typically come from concentrating on bringing out the flavor of each type of food through the use of creative sauces and cooking methods, regardless of their cul-

tural derivation. Don't be afraid, for example, to serve a Middle Eastern dish alongside an Indian or Italian offering. "Taking a multicultural approach to your menu lets you draw on the best elements that each culture has to offer," advises Carrie. "If you do this well, then the dishes will also work nicely with each other."

When it comes to serving the food, the best guide is to focus on the comfort and enjoyment of your guests, starting with how the hors d'oeuvres are presented. "If you're having passed hors d'oeuvres, it's always nice to have one type of stationary hors d'oeuvres as well, such as a salad, set up at various points around the cocktail area," says Carrie. "That way, the minute guests arrive they have something to munch on, in case the waiters don't get to them right away."

Besides being fabulously flavorful, all passed hors d'oeuvres should also be bite-size and not messy to handle, so that your guests—who will all be holding a drink in one hand and conversing—can pop them directly into their mouths without being forced to wrestle with a plate and napkin. Also, the demeanor of the waiters bringing them around should be elegant and relaxed—never rushed.

If your main courses are being served on a buffet table or food stations, think twice about asking guests to ladle food onto their own plates. Yes, hiring servers to man the buffet

table can add considerably to the overall expense—but it will also enhance your guests' experiences immeasurably to have someone serve them their food while describing each dish and its ingredients and, if necessary, explain how to apply the appropriate sauce or dressing. Also, keep in mind that, from your guests' perspective, two buffet tables are better than one, since they allow two groups at a time to approach the buffet and be served. Finally, a good caterer will make sure that any food served buffet-style or at food stations is constantly being replenished and its presentation refreshed, so that those at the back of the line have the same pleasurable experience in getting their food as those at the front.

RIVER OF DREAMS

*C*hris proposed to Melita in April, and the couple decided to tie the knot that same summer. "No sense in dragging out the process!" laughs Melita. The two of them are both known for their freewheeling style, and they wanted a wedding that reflected their personalities—a casual and nontraditional celebration where their friends could relax and kick up their heels. They also wanted the gathering to be an expression of their love for each other, and of the sense of community that they shared with their friends and family.

For the kind of wedding they had in mind, they knew that the setting had to be very special. "Since neither of us is active in any church or religion, a church wedding was never an option," says Melita. "And because we live in Colorado, where the

countryside is gorgeous, the idea of being outside in nature and mountains really appealed to us."

After scouting out a few parks and other outdoor spaces, they found themselves drawn to a site called Planet Bluegrass, located in the foothills outside of Denver. An old homestead that's now used as an outdoor concert venue, the place is famous for its spectacular location on the edge of a mountain stream that, over the centuries, has cut into the mountainside to form a hundred-foot-high cliff of red stone on its far bank. When they were dating, Chris and Melita had visited Planet Bluegrass several times for an annual three-day rock and bluegrass festival known as Rockgrass. "We already had fond memories of the place," says Melita. "Plus it's so pretty there, with the river and the cliff. We knew it would make a great backdrop for the ceremony and the reception."

They called the place to ask if it was possible to rent it for a wedding, and were told that they could. As part of the deal, Planet Bluegrass would also supply an open-sided tent and chairs for the guests, though Chris and Melita would be responsible for setting up the chairs themselves. Any food and drink would have to be brought in by the couple.

"It was just the sort of atmosphere we were looking for," says Melita. "We knew the whole thing was going to be very informal. To get married in Colorado, you don't need a third

party like a minister or a justice of the peace. Instead, two people can simply get married on their own, and that's exactly what we planned to do." Just in case anyone had any doubts about the casual nature of the celebration, the wedding invitations requested that people come dressed in shorts and river shoes—adding, "we'll be playing in the river."

The afternoon of the wedding was a classic Colorado summer's day: Clear and sunny, with temperatures in the low nineties and no humidity to speak of. At one point, a small thunderstorm threatened in the distance—also typical of the Colorado Rockies—then passed by. When the ceremony's scheduled start time rolled around and some of the guests still hadn't shown up, no one blinked an eye. Indeed, the couple had expected as much and had made preparations ahead of time. "A lot of our friends are quite good brewers of beer, as is my husband, and they all donated kegs of their own home brew," Melita says. "The kegs were already set up under the tent next to the river, and we went ahead and tapped them before the ceremony so people could enjoy themselves until everyone got there."

When all of the guests had arrived, they assembled with the couple by the side of the river, framed by the rushing stream and the red cliff looming up behind it. There were no ushers—guests just sat where they wanted. The groom and his

brother, the best man, wore short-sleeve button-down shirts and shorts. Melita's sister, as matron of honor, was dressed in a blue sundress and sandals, while the bride wore a white linen dress she'd made herself, a wreath of daisies and blue delphinium on her head.

Standing up front with them to help facilitate the ceremony was their good friend, Michelle, who'd been there when Chris and Melita first met. A string quartet made up of four other friends provided the music for the ceremony. "I chose 'Jesu, Joy of Man's Desiring' for my processional," says Melita. "Of course, my dad walked me down the aisle. He didn't get to do it with my sister, so this was his only chance!"

After the ceremony, the newly married couple stood in a receiving line and posed for photos as the guests made their way back to the beer kegs, now supplemented by appetizers, red and white wine, and champagne. Then Melita and Chris called their guests together for the toast, and sprang their surprise.

"Chris and I waded out into the middle of the river—I had my wedding dress pulled up over my knees," recalls Melita. "Then we invited any guests who wanted to come out and join us." About two-thirds of the guests waded into the stream. (Despite the invitation's instructions, a few people had dressed in their Sunday best, so they wisely stayed on the riverbank.) The best man and matron of honor each gave a toast, and then

the celebrants stood sipping their champagne, enjoying the moment and the sensation of the chilly glacial waters swirling around their ankles and calves in the mid-July heat. "It was awesome," says Melita.

Someone had brought a box of cigars and began handing them out to the guests, who lounged in the shade of the trees that dotted the riverbank, enjoying the refreshments and the spectacular weather. What happened next wasn't planned, but it encapsulated the spirit of the celebration perfectly. "Planet Bluegrass had a number of large inner tubes stacked near the river," explains Melita, "and basically we commandeered them." People began jumping into the tubes and floating with abandon under the dazzling blue Colorado sky in their wedding clothes, home-brewed beers and cigars in hand. For the couple, it was everything they wanted their wedding to be. "It was a wonderful way to spend our wedding day," smiles Melita.

Dinner took place under the tent by the river. Like the rest of the day, it was a strictly casual affair—the food, brought in by a local caterer, was served up buffet style, and there was no assigned seating. "Chris and I had plenty of opportunity to relax, walk around and talk with everyone. I can't remember if we ever sat down to eat or not," Melita says. "One of the caterers was nice enough to make me a to-go box of the food, which my sister

took home for safekeeping that night, so I could eat it later. But my grandmother, who was staying with her, ate it for lunch the next day. So I'm still not sure if I liked the risotto or not!"

Chris and Melita's first dance was to a CD by a local band, Runaway Truck Ramp. "Their concert was our first official date," Melita recalls. "Then my dad cut in, which was so touching to me. He was doing such a great job as 'father of the bride.'"

After dinner, there was dancing, more tubing down the river, and more cigars for the guests. As a special gift, the bride's sister had made a handmade book with blank pages; she then set out Polaroid cameras at the wedding and asked guests to take photos of themselves and paste the photos in the book along with a message to the couple. Even the bride's grandmother posed for a photo with stogie in hand. "It was *way* better than any guest book could ever be," says Melita.

"More than anything else, our overriding memory is of feeling very, very happy," she adds. "It turned out to be just a really fun party. What really made the day for us was having the wedding in such a beautiful and dramatic place. Our closest friends loved everything about the celebration. And while our families were accustomed to more formal affairs, they really got into the spirit of things. People still bring it up when they're talking about memorable weddings they've been to."

MELITA AND CHRIS'S MOST MEMORABLE MOMENT: *"Celebrating with the champagne toast in the river. It was so great, looking out at everyone gathered around us having a good time, and thinking, 'We did it—now let's party!'"*

Planning an Outdoor Wedding

There's nothing like an al fresco wedding: Being joined together for life under the open sky, and then celebrating with your guests in a lovely, natural setting. But there's a catch: Being outside puts you at the mercy of the elements—hence, the one cardinal rule for any outdoor ceremony and/or reception: *Have a backup plan in case it rains or turns unseasonably cold.*

Exactly what this backup plan consists of will depend on where you're getting married, and what aspects of the wedding you're planning to hold outdoors.

If you plan to have just the ceremony outside, followed by an indoor reception, then the most workable foul-weather alternative is usually simply to switch the ceremony to the reception site. On one of your visits to the reception venue, spend a little time with the site manager figuring out where you might locate the guests' chairs, lectern, flowers, and musicians, in the event you have to move the ceremony indoors. Then, if the weather does turn threatening on your wedding

day, make the call to shift inside as early as you can, to ensure that the whole process is carried out smoothly—and have a mechanism for letting your guests know of the change as soon as it's been made.

If you plan on holding your reception outdoors, then there are two approaches you can take in terms of a backup plan: If the reception is planned on the grounds of a restaurant, inn, or historic site, it's very likely that the establishment will agree to make the indoor facilities available for the reception if bad weather strikes. You can't assume that this option is available, however, which is why it's absolutely essential to discuss rain-out plans in detail with the site manager *before* deciding on the venue.

If there is no available indoor facility attached to the outdoor site you have in mind, then there's only one thing to do: *Arrange for a tent*. This doesn't mean you'll necessarily use it. One approach is to place a hold on a tent, by putting down a nonrefundable deposit (which can range from a couple of hundred dollars up to a third of the total cost of the tent) and then, depending on the weather forecast, letting the tent company know a day or so before the wedding whether you'll actually be needing it.

Most experts agree, however, that your best move at an outdoor reception is to plan on putting up a tent covering no

matter how fine the weather promises to be. For one thing, caterers often will be reluctant to leave their tables, linens, and china exposed to the elements. A tent will also protect your dance floor and any electrical equipment being used by the band or DJ. If the wedding is being held in the evening, a tent also allows the option of lowering the sides and possibly even providing a propane heater with blower to keep guests warm. Even on a hot afternoon, a tent covering can offer some welcome shade—leaving guests free to step outside the tent into the sunlight whenever they wish.

If you're using a wedding planner, he or she can easily arrange for a tent rental. Otherwise, you can seek out a tent company on your own, via the Yellow Pages or the Internet, or check with your caterer to see if they can recommend one (some caterers will even subcontract out the tent rental themselves). The cost will vary according to your needs: A light awning can often be erected for less than $1,000. A large pole tent, on the other hand, may range from $1,000 to $2,000, depending on the size of your guest list.

If the wedding is going to include music and dancing, you'll also need to rent a portable dance floor (often the tent company can supply this as well). And unless there's a nearby building that you can run an electric supply from, you'll probably want a portable electric generator as well (typical

cost: around $500)—especially if you're planning to have a DJ or electrified instruments, or electric lighting for a night reception. You'll also need to evaluate the available restroom facilities and decide whether you need to rent portable toilets for your guests. Finally, a propane heater can come in very handy, especially if you're planning a night wedding in the spring or autumn (cost: around $200). For a small deposit you can usually place a hold on a heater, then decide a day or so in advance whether it's needed or not.

By the way, these issues are equally pertinent if you're planning to hold a backyard wedding. Think about it: Are you prepared to run an entire band off your home's electrical supply? And do you really want a hundred or more guests trooping inside to use the bathroom—or moving inside *en masse* in case of a sudden rain shower? On reflection, renting the necessary equipment to ensure a smooth, stress-free outdoor reception is usually well worth the additional expense.

A few other tips:

* Since an outdoor site also impacts any wedding professionals and vendors that you hire, it's important to ask if they're willing to work in an outdoor location—and whether this will cost extra—before signing them up. If you're using a caterer, find out

what experience they have with outdoor locations, and what arrangements need to be made for preparing and storing food and beverages.

✳ If reservations or a permit are needed for your desired outdoor site, you'll need to take care of this issue first, before proceeding with any other plans.

✳ Take a careful look at transportation and parking. If there isn't a large parking area close by, you'll need to make arrangements to transport guests to the site in shuttle buses or cars.

✳ Accessibility is another important factor. If any people on your guest list have trouble walking, arrange for these people to have escorts where necessary.

✳ Last but not least, providing some small amenities for your guests can make a big difference in their enjoyment level. If your guests are going to be in the sun, be sure to have plenty of sunscreen and bottled water on hand. The same goes for bug spray, if insects are a potential problem.

FROM RUSSIA WITH LOVE

*O*leg and Tatiana live in Moscow, where he's a film producer and she's a jewelry broker with her own string of jewelry shops. Being both romantics and cosmopolitan world travelers, they wanted a wedding that would transport them, their families, and their friends to an enchanted world. They were also in the fortunate position of having the resources to make their vision a reality without worrying unduly about what it would cost.

Since their guests would be coming from all over the globe, their first challenge was to decide exactly where the wedding would take place. "Our choice was between northern California, where a number of Oleg's family live, and Italy," says Tatiana. "Oleg planned a trip to Napa Valley for us, where he

had set up appointments to see quite a few different places—vineyards, hotels, monasteries, even the museum of modern art. He had saved Beaulieu Gardens for the very last. He was pretty sure it would be the one place I would really love, but he wanted me to see all the other possibilities first."

Beaulieu Gardens is a private residence surrounded by European-style gardens, all set amid a vineyard in Rutherford, California. In an area known for great wedding venues—Napa Valley is, after all, one of the most popular wedding destinations in America—Beaulieu is one of the region's most sought-after locations. The Elaine Bell Catering company has an exclusive contract for all events held there, and their representatives served as Oleg and Tatiana's escorts when they toured the estate.

"My sister-in-law had been a guest at a wedding there, and she told us how beautiful it was," says Tatiana. "I fell in love with it as soon as we walked through that long entrance. It has a French garden and an Italian garden, both of which reminded me of parts of the Europe that I love. The whole place felt European to me, while at the same time it was so gorgeous and sunny, with trees and roses and shadows and wonderful smells!"

In a stroke of serendipity, while strolling around the estate the couple happened to bump into someone that Elaine Bell

had already been planning to introduce to them—Dee Merz of Everlasting Memories, one of Napa Valley's most experienced wedding planners, who was there showing the gardens to another soon-to-be-married couple. It was mutual admiration at first sight. "We were so lucky to work with Dee," says Tatiana. "She is so careful about all the details, and truly professional—but at the same time warm and personal, never overly business-like. She was there for us always, whenever we needed her."

"It was an immediate connection," agrees Dee. "Oleg and Tatiana are among the most gracious people I've ever known."

They continued to correspond by e-mail. A month later, when Tatiana came through Los Angeles on business, Dee flew down from the north and they met over lunch to begin mapping out the specifics of the wedding. For starters, the couple's choice of Beaulieu Gardens meant their wedding would be larger than they'd originally envisioned. "We were thinking at first of having just our family and closest friends," says Tatiana. "But Beaulieu requires a larger group than twenty or forty—and that was definitely the place we wanted for our special day—so the wedding started getting bigger."

Besides discussing the size of the guest list, which they agreed would be around one hundred, Dee and Tatiana also talked about the spirit of the wedding—establishing that it was going to be formal and very elegant, that the guests would

be taken care of superbly, and that the wedding would be a sumptuous affair with "lovely tables, handmade linens, and gorgeous flowers," employing a color theme of cherry red. "I *love* color," smiles Tatiana, "and I'm not afraid of having a lot of it!"

They also formalized their working relationship, agreeing that Dee would, in her own words, "take care of everything but the wedding gown." With connections to key wedding vendors in Napa Valley, she was the perfect partner for Oleg and Tatiana as they took on the challenge of planning a wedding halfway around the world. Since the couple had already picked a wedding date of August 25, the very first thing Dee had done—knowing how committed they were to Beaulieu—was to see about reserving the estate for that day. Luckily, it was available, so Dee put a hold on it until that time when all the contracts were signed and the deposit money wired from Russia.

Early that year, the planning process moved into high gear as Oleg and Tatiana flew from Moscow to northern California to join Dee for two days of wedding-related appointments she had set up for them. The first of these was a three-hour session with Grant Rector, a leading floral designer. In preparation for the meeting, Grant's studio had been filled with buckets of richly scented flowers in Tatiana's favorite colors—reds, pinks, whites. A luncheon was brought in, and as they nibbled, Grant

listened carefully while the couple told him what they wanted, then presented them with a variety of ideas.

"He is a great guy, with outstanding taste," says Tatiana. "The good thing about working with Grant is that he was never insisting on anything. We just looked through albums of pictures and samples of flowers, while he asked about what flowers we felt good with, and what smells we liked. We tried different floral arrangements and decided on a theme of red and pink roses. The next day, Grant brought us a wonderful pot of garden roses from Ecuador. He said, 'This is what I found in the market, and these will be your flowers if you like them.' They were exactly what I had in mind. They smelled great, and were big and beautiful, with a wonderful rich color."

During the meeting in Grant's studio they also selected a deep red fabric for the table linens and discussed the china, crystal, silverware, and the chairs and tables that would be used for the reception. "We didn't want the tables to be standard sizes," notes Tatiana. "We wanted the central table, where Oleg and I and the wedding party would sit, to be an oval table that could seat twelve, because the oval shape gave better views of the guests. For the rest we wanted a mix of round tables and square tables, each tailor-made for a different group of eight, ten, or twelve people, depending on the table. This is not the

usual approach, but Dee and Grant and Elaine Bell kept saying to us, 'Everything is possible.'" Finally, it was decided that the oval table would be designed by Grant himself especially for the wedding, while the others would be rented from a local supplier.

They made another stop at Elizabeth Hubbell Studio to plan the invitations and other printed materials. "She has this fantastic ancient hand-letter press that she uses to print everything by hand," says Tatiana. "I'm very keen on luxury stationery. I wanted to do a big-sized invitation and keep it very simple—the opposite of those little cards with lots of information on them." They discussed the various items and materials the couple had in mind, and an estimate was prepared. Elizabeth also came up with a design of raised cherry-red type set against paler red and gold background images of plants, flowers, and fruit, all printed on heavy, cream-colored card stock.

The first item they tackled was the save-the-date card—a long single page of card stock sent out in a rust-red envelope, with the date and location of the wedding and a note in small type at the bottom for those desiring more information, containing the name and number of Tatiana's personal assistant as well as the address of the couple's wedding Web site (a wedding gift to them from Oleg's best man).

The invitations themselves were seven-by-ten-and-a-half

inches, and were sent out along with a slightly smaller hand-printed card containing the guests' itinerary for the three-day celebration, all in an oversized cream envelope of heavy, rag-edged stock. Names and addresses would be hand-penned later in English by an American calligrapher for English-speaking guests, and in Cyrillic by a Moscow-based calligrapher for Russian guests.

Other items included a welcoming card that greeted guests on their arrival, with directions to various local restaurants where reservations had been made and a detailed timeline of the wedding day; a ceremony program; a folded card with the wedding feast menu printed on it; escort cards to guide each guest to their table, which would have the guest's name written in calligraphy on the back, and would be hung from a long cherry-red linen under an arbor for guests to pick up after the ceremony; and finally the large table cards themselves, with a hand-printed map of Napa Valley on the front and blank space inside where that table's guests could down write their thoughts and wishes for the couple. "We didn't want a big guest book that people would have to stand on line and wait to write in," explains Tatiana. "This way we would have these beautiful cards, with everyone's best wishes, to keep forever."

The next day was the menu tasting in the dining room at Elaine Bell's. "It was amazing," marvels Tatiana. "First you're

seated as if in a restaurant, and then you're served the way you would be at a wedding, given lots of things to choose from. They had sent us a list of hundreds of dishes, and from these we selected fourteen appetizers, several first courses, and several main courses to taste. It was quite an experience, especially just a couple hours after eating a lavish breakfast at the inn where we were staying!"

After being greeted by waiters bearing a pre-wedding drink—highball glasses glowing red with raspberry-pomegranate lemonade—the couple sat down and tasted appetizers of duck and paté, black-currant lollipops, nori-wrapped albacore tuna, smoked chicken brioche canapé, Bloody Mary crab gazpacho, and figs stuffed with goat cheese and arugula. Of the first courses, they especially liked the spiced confit of duck with curried couscous. They also settled on two main courses—rack of lamb and Alaskan halibut. It was decided that enough of both courses would be prepared to ensure that all the guests could opt for either dish at the reception, rather than requiring them to state a preference for one or the other months ahead of time. Elaine Bell also agreed to come up with a selection of first-class local wines to serve at the reception.

"After that, we went to the cake place that same morning, where we had to do it all over again," recalls Tatiana. "I was saying, 'I don't know if I can take it!' They offered us fourteen

different slices, each with a different filling, and asked us to choose the one we liked best. We said, 'Can't you choose yourself?'" The bakery, Perfect Endings Bakery, known as one of the premier cake makers in northern California, explained politely that they didn't work that way. Somehow, the couple managed to eat their way through all the cake samples and make their choice. "It was quite impossible," sighs Tatiana. "But the cake was *very* good."

Several months later, Tatiana came back through the area on a business trip, and she and Dee had a second round of meetings with their vendors to fine-tune the wedding plans. They repeated the menu tasting, made some adjustments to the table setting—adding some red stemware and red-handled cutlery, among other things—and reviewed ideas for the cake design. Meanwhile, Dee had been busy making wedding-week reservations for spa appointments, restaurants, wine tours, and other activities that guests might be interested in, as well as securing hotel rooms, hiring shuttle buses to bring guests to the wedding venue, and finalizing arrangements at the rehearsal dinner and post-wedding brunch sites. She and Tatiana exchanged daily e-mails and scheduled a regular weekly phone call, so the couple could stay up-to-date on what was happening.

As the wedding day approached, Tatiana and Oleg chose presents for their wedding party—silver money clips for the

men, with the date of the wedding engraved on them, and engraved silver charm bracelets for the women—and selected their own wedding rings. "We picked out white-gold bands, but my idea was that we would put two stones on the inside of each one, so you couldn't see them when they were being worn, but you knew that they were there." Inside Tatiana's ring were set two rubies, for passion, and inside Oleg's, two diamonds, for constancy.

In the end, some ninety guests journeyed to Napa for the wedding. Because so many were traveling great distances, there were a number of late RSVPs, which led to a bit of scrambling for hotel rooms in Yountville—the Napa town where all the guests would be staying, just ten minutes' drive from the wedding site—and some last-minute reworking of the seating charts.

"Not everyone we invited could attend, of course," says Tatiana. "Still, so many did travel to be with us, and we appreciated it so much. We had all of our family, which was wonderful, and all the people close to us who really wanted to be there. That's why we really enjoyed planning the three days with this big group of people, all meeting on the other side of the world. People came from everywhere—from Russia, Italy, different parts of the United States, Kazhakstan in central Asia, Denmark, England—all over. It was great to be in middle of it."

Once the guests began to arrive at their hotels in the small town of Yountville, the couple was able to concentrate fully on their special moment. They found it comforting to know that Dee was on hand to help welcome the incoming travelers and handle any problems that might crop up.

For the bridesmaids, flower girls, and mothers of the bride and groom—many of whom didn't see their dresses until arriving in Yountville—the day before the wedding included stops at a formal-wear shop next to the hotel, where the resident seamstress stayed busy making any needed alterations to the gowns. Dee had also arranged a ladies' luncheon at a restaurant, in which a table had been specially decorated with flowers and other small touches, where the mothers of the bride and groom met for the first time. "The setting was just exquisite," says Tatiana, "and the lunch went wonderfully."

That night, while the bride and groom and their families and wedding party held their rehearsal dinner, other guests dined at a number of nearby restaurants, all within walking distance of their lodgings. Then, shortly before nine o'clock, the rehearsal dinner was thrown open, and all the guests joined the wedding party for cocktails and dessert.

The next morning, like virtually every summer day in Napa Valley, dawned clear, sunny and temperate. The wedding ceremony was scheduled to begin at four in the afternoon. Dee

had arranged for The Dream Team, a firm of makeup artists and hairdressers, to set up a salon in Tatiana and Oleg's hotel, complete with breakfast buffet, for the bride and her attendants. After the bridal party finished their preparations, the team kept the salon open for any other guests who wanted to use their services.

As the four-o'clock starting time for the ceremony neared, buses picked up guests at their hotels and ferried them to the wedding site, in a formal garden on the Beaulieu estate. It was a simple but beautiful service: A relative of Oleg's supplied the music for the ceremony on his guitar, and the only adornment, aside from the garden itself, was a pair of large white floral compositions that framed the couple—she in a Vera Wang dress handmade by the famous designer herself, he in a formal black suit with bright red tie—and the priest, who contributed to the wedding's color theme by wearing a stole of rich red around his neck. The seats were white, as were the bows on the small bells that the guests were given to ring when the priest declared Oleg and Tatiana to be husband and wife.

Following the ceremony, the guests moved to an adjacent Italian garden for cocktails, then headed over the bridge to where the dinner tables had been placed under an arbor of trees, their red linens echoing the bright pink and red table flowers. Cherry-red candles were also set out, and red paper

lanterns had been hung around the garden. Following a break for photographs, the festivities began at six o'clock, and the meal unfolded amid toasts and merriment as twilight slowly fell over the garden.

Next to the dining arbor, a lounge area had been set up under the stars, with carpets spread out and comfortable chairs and sofas scattered about, and sorbet, chocolates, and other bite-size snacks in easy reach. The lounge bordered on a dance floor and bandstand. Midway through the meal, the big band hired for the occasion struck up a dance tune and the guests descended on the dance floor to stay. By a stroke of luck, one of the musicians was Russian and could play and sing classical Russian folk music. "He was terrific, playing all the songs that were favorites of Oleg's parents. We Russians loved it, and all the foreigners loved it, too," says Tatiana. "Everyone was dancing, young and old."

The reception ended at ten, when, as planned, the celebration moved to the after-party on the patio of a bistro in Yountsville. Throughout the night, Dee kept the buses ready and available for all the guests, so no one had to worry about driving.

The following day, the farewell brunch was set in another local winery, where one long table was set up on the very edge of the vineyard itself. With birds chirping, the mountains in

the distance, and even a local wine train chugging slowly along its track through the middle of the grape vines, it felt for all the world like Europe—a home away from home for Tatiana, Oleg, and their compatriots.

Later that day, when it came time for everyone to go their separate ways, Tatiana's mother had one last wedding gift for her daughter and her husband. "These wonderful pears had been set out on the tables at the reception—really for decoration more than anything else," recalls Tatiana. "But they were so delicious that people started eating them. My mother kept one and gave it to us for our trip home."

Several months later, Tatiana and Oleg were still basking in the memory of it all. "This was my first American wedding ever," says Tatiana. "It was quite an experience to plan everything. In fact, for the first couple of weeks afterward, I was really missing this part of my life—conference calls every week, the constant e-mails. I saved everything in a notebook. It was more than a year of thinking and planning out every sort of detail. Oleg and I really enjoyed it. We all have our special stories, I suppose. That's what we did for our wedding."

TATIANA AND OLEG'S MOST MEMORABLE MOMENT: *"After the ceremony, there was a half hour set aside for taking photos of the bride and groom. We took a walk inside the gardens, just us with the photographer. It was so beautiful, and we were so genuinely happy to be in this lovely place, walking through this vineyard together, having just gotten married. We held hands, and laughed, and tasted some grapes, and simply enjoyed having this wonderful half hour just to ourselves."*

Hosting a Multiple-Day Wedding Celebration

If you're planning a wedding that involves a number of guests who are flying or driving long distances to your wedding location and booking hotel rooms, the chances are very good that all or most of them will be staying for more than one night—in many cases, three or even four nights. In fact, this is one of the key challenges of planning any destination wedding: You not only have to arrange the details of the wedding itself but you're also responsible, at least to some degree, for ensuring the comfort and well-being of your entire guest list over a period of several days, from the time they arrive at your wedding locale until they head back home.

How to pull off this rather monumental feat, while still keeping your own energies focused on your impending mar-

riage? One of the keys, says Dee Merz of Everlasting Memories, a wedding consultant based in California's Napa Valley region, is the setting. You should try to arrange for all of your guests to have lodgings in the same hotel or a nearby group of hotels—preferably in an intimate town or city neighborhood that has plenty of good restaurants and other amenities within walking distance, and that's not far (ten minutes' drive or less) from the sites of the wedding ceremony and reception.

"Ideally, your guests should be able to arrive, park their cars, and then forget about them for the rest of their stay," says Merz. "Part of the fun of a destination wedding is to spend several days exploring a charming area on foot. This also gives guests a great chance to mingle and get to know each other over the course of the wedding."

You should also provide all of your guests with information on travel and lodging well in advance of the wedding, along with an itinerary of wedding events. This information should ideally be sent out on a separate sheet in the same envelope as the save-the-date card. If you're planning only to send out invitations, then include the information either on separate stationery as part of the invitation packet, or in a separate mailing sent out at the same time. Alternatively, if you have a wedding Web site, the information can be posted there, preferably with links to designated hotels and airlines. Just make

sure all of your guests have access to the Internet and know the address of the Web site.

The *travel and lodging information* should include: Details on various flights from the guest's home area, as well as transportation options from the airport to the wedding lodgings; the names, street addresses, phone numbers, and e-mail addresses of the hotels where guests will be staying; directions for any people who may be driving; and the name, phone number, and e-mail address of the person to contact for further information.

The *wedding itinerary* should list the dates, times, and locations of all wedding-related events that guests are invited to, including the ceremony and reception, an after-party, if there is one, and the farewell brunch the next day, as well as information on how to RSVP. Suggested attire can also be noted for each event, if you think it will be helpful.

When selecting hotels to house your guests in, it's thoughtful to choose hotels in several different price ranges, in order to accommodate a range of budgets. As soon as you've decided which hotels you'll be recommending to guests, call each hotel and reserve a block of as many rooms as you think you may need for the days in question. When you send out lodging information to guests, simply note on it: "Rooms have been set aside for the Smith-Jones wedding party at the following hotels . . ."

Another considerate touch is to identify some local restaurants that you think your guests might enjoy—particularly those who might not be participating in the rehearsal dinner on the night before the wedding—as well as local spas, tours, and venues for activities like swimming, golf, or tennis. If it's possible to make advance reservations at any of these places, you might consider doing so—with the understanding that you'll check in with them once guests arrive, to confirm whether the reservations will be needed or not.

Once your wedding guests arrive in town, here are some tips on how to make sure that everyone has a carefree, relaxing, and enjoyable stay:

* Have welcome packages waiting for arriving guests, including a packet containing information on local dining and other options and another copy of the wedding itinerary. There's nothing nicer than stepping into your hotel room after a long journey to find a thoughtful gift and an expression of welcome waiting for you! The welcome package can be left either in your guests' rooms or at the front desk with their names attached. The package itself could be as simple as a bottle of sparkling water and some light snacks, or as elaborate as a selection of local gourmet foods and

wines. It should also include a note from the bride and groom welcoming the guests to the celebration. The enclosed information packet might contain a list of recommended local restaurants—including directions on how to get to them—possible activities the guests might enjoy, and a map of the local area along with some driving suggestions, in case the guests care to do some touring.

✻ Don't overload guests when they first arrive. If possible, try to avoid any planned activities for guests on the day they first arrive in town. This is a time when they'll want to be able to relax, unpack, recuperate from their trip, and enjoy exploring their new surroundings at their own pace.

✻ Choose someone to be your designated on-site contact for guests. The last thing the bride and groom need in the days leading up to their wedding is to be fielding questions from guests. If you haven't used a wedding consultant up to this point, this might be the time to hire someone for a few days. A savvy consultant will make him or herself known to all of the guests at the time they arrive, and will be available around the clock to answer questions, help arrange dinner res-

ervations, and serve as an all-around support staff and troubleshooter. Alternatively, you might designate a reliable relative or member of the wedding party as the "go-to" person for any questions or problems guests might have.

✳ If the rehearsal dinner is going to be limited to the couple's families, attendants, and other close friends, consider opening it up to the other guests later in the evening. Inviting one and all to join the rehearsal dinner attendees for drinks and dessert, after the other guests have enjoyed dinner on their own at other local restaurants, is a great way to kick off the full-scale celebration early, while still ensuring that the rehearsal dinner itself is a more intimate gathering.

✳ If possible, arrange transportation for all guests to the wedding ceremony and reception and to the after-party, if there is one. Even if the reception site is quite close to everyone's hotels, your guests will appreciate not having to drive themselves there and back—especially if they plan on consuming alcohol. The most practical option is usually to rent several mini-vans or small buses. Tip: Let guests know exactly when the buses will be assembling to take them to the ceremony,

and keep the buses running and available throughout the reception and after-party, in case guests need to make a quick return trip to their hotel room for any reason.

* Be sure your guests know that all extracurricular activities are purely optional. Only formal wedding-related events should be included on the wedding itinerary. Make it clear that any other suggested activities listed on guests' information packets are just that—suggestions for guests to explore, if they're so inclined. If they want to play golf or tour a winery, great. And if they want to lie back and catch rays by the pool, that's great too.

* Keep the farewell brunch relaxed and flexible. Ideally, the brunch on the day following the wedding should begin right around whatever the checkout time is at your guests' hotels. If you know that some guests will be departing earlier than that, then you may want to start the brunch a bit earlier. If everyone is gathering at exactly the same time, you might consider a plated meal. If you expect guests to be arriving at the brunch over an extended period, however, a buffet or service that lets people order individually is a better

approach. Finally, remember that this brunch will be people's last impression of the place you've all shared for the last few days. Holding it in a relaxed, visually beautiful setting will help guarantee that the memories they take away with them will be stellar ones.

a wedding potpourri

In the preceding pages, you've read detailed accounts of a dozen unique weddings. But in fact, *every* wedding is unique— a ceremony and celebration made up of the couple's own mix of traditional customs and more personal touches. To give you a sense of the rich variety of ways in which you can personalize your own big day, the following pages contain a collection of shorter stories—a wedding potpourri, if you will—showing how various couples have used their imagination to create a wedding day like no other.

SPECIAL TOUCHES

*W*eddings have many elements: The gathering of family and friends, the marriage ceremony, the food, music and décor, and all of the special moments that make up a wedding day. Often, however, it's one heartfelt aspect of a wedding that makes it especially memorable for everyone involved. A special, personal touch—a theme, a toast, or a symbol that sums up the feelings of the bride and groom and those close to them—is a way of bringing everyone together in the spirit and emotion of the wedding celebration. And isn't that what a wedding is all about?

A Toast with Champagne and Roses

Lisa and Tim had a destination wedding and honeymoon, followed by a celebratory party for their friends at a museum in Baltimore, where they lived. Both of them are artists, and are involved in an art movement called Fluxus, which embraces the philosophy that art should be incorporated into everyone's daily life—as part of the space you live in, the clothes you wear, even the food you eat.

They wanted to share their artistic philosophy with their guests in a casual but memorable way, by doing something that people could also have fun with. They performed a piece by Fluxus artist Ben Patterson, which began under the partygoers' noses—literally. The reception took place at a theater built inside a historic home, with tables for dining. For the centerpieces, the couple placed vases containing roses. After dinner and before the cake was served, Lisa and Tim called for the guests' attention. Ahead of time, Lisa asked all of the children in attendance (of which there were quite a few) to dance around the tables, plucking the roses out of each vase they passed along the way. The music was a tango by Astor Piazzolla—fun and exotic.

The children moved among the diners, giggling as they gathered the roses. One by one, they brought the roses up to

the bride and groom. As the children handed the roses to Tim and Lisa interchangeably, Tim held the thorny rose stem in his mouth (tango style) while Lisa slowly pulled the rose blossoms off the stems and dropped them into an electric blender sitting on the table next to them.

After the roses were handed to Lisa from Tim and the children, she put the top on the blender, and whizzed up the rose blossoms—spiked with sherbet for texture—into a frothy pink liquid. They then poured out the mixture into champagne glasses, linked arms, and drank it down together to cheers and applause.

A Touch of the British Isles

One of the most personal ways to customize a wedding is to bring in themes linked to your own romantic history as a couple. Justin and Lea had known each other for some time as friends, but they didn't start dating until several years after they first met. "We fell in love during a church trip to Great Britain," says Lea. "One of the most memorable parts of the trip was sharing afternoon tea together."

When they got engaged, the couple knew they wanted their wedding to reflect a bit of the place where they fell in love. "We were on a tight budget," Lea says, "so we decided to have a

smaller wedding that featured an afternoon tea reception. It was the perfect way to celebrate our marriage."

The wedding took place in late April in their church, with the reception in the adjacent parlor. Because the couple knew exactly the sort of reception they wanted, they were able to focus much of their attention on the most important part of their special day: The ceremony. "It's easy to lose perspective," notes Lea. "So many people get lost in the party aspect of planning their wedding. We didn't want that to happen to us. We felt that the actual marriage ceremony represents the essence of what a wedding is all about, so we spent a great deal of time deciding on all of the details involved in our ceremony."

Both Justin and Lea are musicians, a shared passion that was another important part of their relationship. So, too, were the majority of their guests, many of whom had agreed to contribute their talents to the occasion. The couple put a lot of thought into selecting just the right music for the ceremony. "We chose a biblical text that incorporated music, and asked our dearest friends to sing various parts," says Lea. "Our most poignant memory is of the moment just before we said our vows. The pastor had finished his sermon—a beautiful message that focused on music, since he knew we were all musicians—and everyone then joined together in singing 'Be Thou My Vision,' an old Celtic hymn."

Not only was it a hymn that the whole congregation knew well, notes Lea, but it also stirred memories of being in England, where they fell in love. As a bonus, it paid homage to Justin's Scottish heritage—a background that the groom underscored by wearing a tartan tie.

The celebration then moved to the parlor of their church. As planned, the theme was an English afternoon tea, complete with scones, petit fours, and tea sandwiches, in honor of the time and place where Justin and Lea fell in love and became engaged. A close friend of the couple's played jazz piano as the musical accompaniment. "I know everyone had a great time, because no one left early!" says Lea. "In fact, most of the guests stayed for several hours until my husband and I departed."

Memory Lane

The bride, Heather, and her maid of honor, Gretchen, were sisters. Heather's wedding to Todd was a fabulous, storybook affair—the summer day was perfect, filled with brilliantly sparkling sunshine, and the bride and groom were surrounded by their entire extended families, including all of their grandparents and scores of close friends.

Then it came time for the toasts to start. Those, too, ran

quite smoothly, with people keeping their tributes short and sweet. Finally, it was Gretchen's turn to propose her maid-of-honor toast to the bride and groom. She had been the ideal honor attendant throughout the wedding process, and now she was visibly moved by the emotion of the occasion. Her words flowed forth, as beautiful as any uttered throughout the day. It was obvious that she had a deep love for her older sister, Heather. Gretchen described their close-knit family, and re-called meeting her new brother-in-law for the first time. Then she turned to Todd and Heather, welcomed him into the fam-ily, and wished both of them a lifetime of happiness.

It was a lovely moment, but the sweetest part was yet to come. Gretchen pulled out a little booklet that she had created over the months leading up to the wedding. It was filled with photos and stories of the two sisters' years growing up together. The book, a complete surprise to Heather, was packed with memories of their lifetime of happy times, right up to the very moment of her marriage to Todd.

The memory book was a huge hit with everybody—an un-expected wonder that put an exclamation mark on an unfor-gettable day. Then Gretchen revealed another happy surprise: Each guest was being given their own copy of the booklet to take home with them. Everyone left the wedding celebration with an extra bounce in their step, feeling the love all around

them, and knowing that they were holding a treasured collection of memories shared by two sisters.

The Candy Bar

Want to give your wedding a special touch that will put a smile on the faces of guests, both young and old? Think sweets: We're talking lemon drops, Mary Janes, jawbreakers, chocolate squares, Smarties, and Gummi Bears galore! No, this isn't a scene from *Willy Wonka*; it's just a few of the delicious items contained in the "candy bar" at Jamie and William's wedding.

The idea sprang from the sweet tooth that the couple shared—and from their shared sweet sense of humor. "We covered a long table with a brightly colored runner," recalls William. "Then on top of that we placed more than a dozen different-size glass containers holding an array of candies, from M&Ms to gumdrops to a wonderful assortment of chocolates." Talk about your open bar! The guests loved the play on words, and *really* loved all the delicious little treats they got to bring home.

Having a specialty bar of candy and chocolates as part of the wedding spread is becoming increasingly popular these days. Whether the spread of goodies is simple or extravagant, having a table devoted to your guests' sweeter inclinations is

guaranteed to add a uniquely memorable and enjoyable twist to your big day. If you like, you can include your own personalized touches as well. Kristin and Troy's wedding featured a small candy bar with all kinds of candies, such as George Washington cherry balls, licorice wheels, and caramel bites, to name just a few. "We also put an assortment of candy into little bags with the words 'Thank You For Coming—Love Kristin and Troy' inscribed on them," says Kristin. "That way, the guests could take a little bit of the wedding home to enjoy later!"

Loons for Life

The lonely cry of a loon (you may have heard it in the movie *On Golden Pond*) is a unique and haunting sound that echoes across northern lakes at dawn. When you hear it, you can't help but wonder what message the bird is sending: A call to its mate that food is on the way for the baby loons? A warning to its young not to wander too far? Or perhaps it's a cry of loneliness for its significant other—because the loon is one of those rare birds and animals that mates for life.

While a nest may have two or more young loons, it's not often that more than one survives. They are a perfect meal for predators around a lake and in the water. A protective parent, the loon guards and cares for its young until they're old enough

to fly and fend for themselves. If you're lucky enough, you may see a loon protecting its offspring by carrying the chick on its back as it swims across a lake.

As a lifetime mate and a parent, the loon is an inspiration—a symbol of what we should all strive for in our marriages. Sarah and Tom took this idea and flew with it. "We now live in California," says Sarah, "but Tom is originally from Minnesota, where the lore of the loon is strong. We knew we wanted to have those loons in our wedding somewhere."

They hit on the perfect solution: "Instead of a wedding couple, we decided to put two glass loons on top of our wedding cake," says Sarah. In doing this, Sarah and Tom transformed an aspect of a traditional wedding that's often an afterthought into a unique, personal statement.

GOING WITH THE FLOW

*i*t's all too easy to get caught up in planning the "perfect" wedding. But many a bride and groom have found that what made their weddings most special were the things they couldn't control. As the following stories show, "going with the flow" by trusting your heart and focusing on what's truly important—the sharing of the day with those near and dear to you, in celebration of two lives being joined together—will make your wedding day far more special than if every detail had gone exactly as planned.

Bridesmaids' Delight

Like many brides, Becca was struggling with the idea of selecting a bridesmaid's dress. She was reluctant to go the tra-

ditional route of asking her bridesmaids to wear the same color and style dress at her wedding, since they all had completely different figures and skin tones. She paged through catalog after catalog, but couldn't find a dress that she felt would flatter and please each of one of them.

"The biggest challenge was my sister-in-law," Becca recalls. "She was eight and a half months pregnant and ready to pop at our wedding!" She sat down with her sister, who was also her maid of honor, and spelled out her conundrum: "My friends are doing so much in preparation of my big day—planning showers and bachelorette parties, buying gifts, making travel plans—how can I possibly ask them to wear a dress that wouldn't make them look their best at my wedding?"

Becca was starting to lose hope when she heard about a friend who had chosen one style of gown, and then let each of her bridesmaids choose the color they wanted to wear. This started the wheels turning: "I loved the concept, but I knew it wasn't going to work with my sister-in-law. Still, I felt there had to be a way to do something similar to this approach, but without a uniform style of dress." As she discussed the situation with her sister, they came up with the perfect idea: Becca would purchase fabric for the bridesmaids' dresses, and each bridesmaid would then have this fabric custom-made into a dress designed to her ideal fit.

Becca went with her sister to a fabric store where they found a bolt of luxurious shantung silk. The light blue hue would easily flatter each bridesmaid's skin tone and complemented Becca's wedding gown beautifully as well. Next, Becca met with every one of her bridesmaids individually to consult with the seamstress at her bridal shop. Each bridesmaid was able to choose her own style of dress—one in which she would feel completely comfortable standing up in front of the wedding guests. As an added bonus, the shop gave them a good deal on the seamstress's fee, so the cost of the dresses was very reasonable.

Leaving the design of the bridesmaids' dresses up to the attendants themselves was a win-win solution all around: The bridesmaids were touched that Becca had taken their comfort and concerns into account; and meanwhile, Becca found a color scheme that she loved. She also felt wonderful knowing that her bridesmaids would be walking down the aisle in dresses they truly liked—and looked terrific in.

The Flight of the Veil

The Texas hill country outside of Austin is a lovely place to get married for starters, but Karen and Christopher's wedding day was particularly dramatic. The ceremony took place outdoors

on top of a beautifully terraced hill, on a sunny and breezy spring day—the perfect sort of day when you feel like nothing could go wrong.

"As we were exchanging our vows, I had the surprise of a lifetime," recalls Karen. "A strong gust of wind suddenly blew over us, and my bridal veil literally took flight, going straight to the chairs where the guests were seated."

Amazingly, it landed smack on the head of the groom's father, who was sitting in the front row. "It's true—my veil nearly smothered my future father-in-law," giggles Karen. "I glanced over at him, and it was almost like we sent a secret message to each other to proceed calmly onward." Christopher's father pulled the veil off his head and folded it onto his lap, she recalls, "showing more dignity and grace than I've ever seen. His poise gave me strength. I did nothing but give him a quick heartfelt smile of thanks before turning back to face our officiant."

It was a small moment but a telling one, and it seemed to cast a glow on the wedding and the life that Karen and Christopher have shared since. "I knew right then and there how lucky I was going to be to have a warm father-in-law who can easily deal with life's dramas," says Karen. "Even now, years later, we all still have fun laughing about this unplanned touch in our ceremony."

Humming Along

Russ and Rita's families and friends had gathered at a traditional Catholic church in Queens, New York, waiting for their marriage ceremony to start. There was trouble, though: The organist was late. The scheduled start time came and went, and the guests were growing restless. The kids in attendance were starting to get antsy, and there was a lot of murmuring and watch-checking among the adults.

After a half hour had passed, the bride and groom realized they needed to go ahead anyway, even if it meant that Rita would walk down the aisle in silence. Having no music for the ceremony would be a disappointment, of course, but they both knew this wouldn't make the ceremony any less meaningful.

The church fell quiet as the bride appeared at the end of the aisle, arm in arm with her father, ready to march up to the altar. And then something miraculous happened: All at once, completely spontaneously, everyone sitting in the pews started to hum "Here Comes the Bride." With the hummed tune filling the church, the bride and her father beamed as they walked up the aisle to where Russ was waiting.

"To hear all of these very human voices, none of them professional singers, filling the chapel was a wonderful thing," recalls one of the guests who attended their wedding. "I still get

goose bumps thinking about it. It was also a delight to see everyone's pleasure at having been so clever and acting together to save the day. It was a moment that united everyone in a special way. And of course, it was the talk of the party afterward."

Our Volcano Wedding

As we've noted elsewhere in this book, anything can happen on the road to your wedding. By staying flexible and calm in the face of adversity, however, you can turn a sudden disruption into a surprising opportunity—and ultimately a wonderful memory.

"Out of our control!" is how Sharon and Thomas remember the moment when their own wedding plans were thrown into turmoil. "We had chosen to get married on a Saturday in a church very close to Mount St. Helens, with the reception to follow at another nearby location," says Sharon. "But a week before our wedding date, the mountain began erupting. We soon realized that we would be unable to get anywhere close to Mt. St. Helens for our big day."

The couple had only a few days in which to switch gears and plan an entirely different wedding and reception. Instead of wringing their hands, however, they got busy. Their first step was to immediately ask a good friend to help them find an

available church in the area, which he did. "We were then able to make all the other necessary arrangements on that Tuesday and Wednesday," says Sharon, "including alternative plans for reception venue, flowers, cake, hotel rooms for guests and family, hair appointments, and so on."

The last step was to get on the telephone and inform their relatives and friends about the change in locale. Their rehearsal dinner that Friday night was decidedly informal—beer and pizza at a friend's apartment—but it was a moment to treasure. "That night was the first time we were finally able to relax, knowing that everything would be okay," says Sharon. "We knew that the only things that could go wrong from that point on were 'normal' things. We ended up with a wedding celebration that was completely unlike what we'd originally planned. But today, over twenty years later, we realize we wouldn't have wished for it to be any other way."

It's All in the Game

"My wedding was pretty traditional," recalls Mary Ellen. "We held the ceremony in a Catholic church in New York City, and it was followed by a reception in a historic mansion. We had a fairly big crowd, around 150 people or so—including my three brothers and a huge amount of uncles and male cousins, all of

whom are diehard fans of the New York Giants professional football team."

Mary Ellen and her fiancé, Duncan, didn't plan it this way, but their wedding day happened to fall on the same day as an important playoff game that the Giants were playing in. "At one point pretty early on at the reception," says Mary Ellen, "I noticed that my cousin Tim had a tiny five-inch television plugged in at one of the tables and was watching the football game on it. I smiled and thought, 'Well, that's just Tim being Tim.' For most of the reception, it was unobtrusive. Some guys came by to watch, but everyone was also dancing and having a good time."

Toward the last hour of the reception, this began to change. "I noticed that a huge crowd had gathered around this tiny TV," Mary Ellen says. "The game was coming down to the wire, and everyone had gotten caught up in it. I guess I could have been disturbed by the fact that all these guys were watching sports at my wedding, but it didn't bother me at all. It had been a great wedding and a wonderful party, and this was just part of the celebration."

Her mellow attitude paid off. The Giants scored a last-minute touchdown to pull the game out and make it into the Super Bowl. "We have the moment on our wedding video and photos," says Mary Ellen. "It was an incredible scene. All

of these men were so happy, the way guys get—hugging each other, laughing and cheering, fists pumping in the air, all of them bonded together by this incredibly exciting moment. It was such a uniting and delightful thing, and it really brought home to me how weddings can bring people together."

The Giants' triumph became the capstone of a fabulous wedding. "On top of that," adds Mary Ellen, "I got a lot of praise from my brothers and cousins for being such a good sport. And they were good sports about it, too. No one went crazy over the game so that it intruded on the reception. There was only a huge crowd watching for a short time—but it made for a lasting memory. Today, the experience still gets brought up whenever our family talks about our wedding day."

YOUR WEDDING YOUR WAY

*t*here are as many different ways to tie the knot as there are couples getting married. As for exactly what your own wedding style is, that's something only you and your intended can know for sure. Following are some examples of brides and grooms who let their hearts guide them to the wedding they truly desired—proving that it really is possible to have "your wedding your way," no matter how unique your own vision might be.

Vows with a View

"The day that Jay asked me to marry him was one of the happiest days of my life," says Louise. "He did it very

traditionally—he went down on one knee with a diamond ring in his hand."

It was when they actually started to think about all the details involved in planning a wedding, recalls Louise, that suddenly the whole process turned from joyful to stressful. "More than anything," she says, "we just wanted to get married and have a day that was wonderful for both of us, with no stress or worries."

The couple had already been planning a trip that spring to the picturesque Colorado mountain town of Telluride, to celebrate Jay's twenty-seventh birthday. Once Jay proposed, it was only a small leap to the realization that they could get married during their visit there—just the two of them—and thus side-step all the wedding details they'd been stressing out about.

The couple rolled into Telluride with nothing but their rings, a marriage license, and happy hearts. Their first step was to do a little reconnaissance and find the perfect spot for their wedding. They had already gotten word of a gorgeous spot, high above town, that was something of a local tradition for couples planning to tie the knot. "The morning after we got into town we hiked up to Bridal Veil Falls, to see if it was as pretty as it looked in the photos," says Louise. "In fact, it was even more beautiful than we thought it would be. We were thrilled to have found such an amazing place to get married."

The next step was to locate someone willing to hike up to the falls and marry them there. "Luckily, we met some townspeople who helped us find an officiant," says Louise. "We met him at the local coffee shop the next day to finalize our plans."

On the morning of their wedding day, Louise and Jay were so excited they could hardly wait for the afternoon to arrive. There was still one last detail to take care of, though—finding a photographer to record the big event. Folks had recommended a local photographer, and the couple approached him to ask if he'd be willing to hike up to the falls with them and take pictures of the ceremony. He agreed, but on one condition: That he could bring along his dog, Charlie.

They all convened at one o'clock that afternoon. It took an hour of steady hiking to reach the spot that Jay and Louise had picked out. The setting was perfect, remembers Louise. "The mountain was covered in spring snow, and the falls were still mostly frozen behind us. The valley stretched out to one side, with Telluride nestled below us and the sweeping San Juan mountains stretching in all directions."

The ceremony was perfect, too: "We exchanged vows with smiles so big we felt as if our faces would break. It was one of the most beautiful places we'd ever been, and it was a stress-free ceremony that was one hundred percent true to who we are."

After spending a few more days in Telluride, the two of

them traveled to the home of Louise's parents for a small get-together. Later, Jay's parents threw a party for them in his hometown. That was more than three years ago. Since then, says Louise, "We've never once regretted our decision to get married the way we did."

A Royal Blue Wedding

Every wedding is its own style of décor, reflecting the venue, the flowers, the tables and place settings, the attire of the bride and groom and their guests, and any other decorative touches the couple chooses to make. But some couples go even further, turning their wedding into a visual work of art.

Carla and Richard had a vision of a wedding suffused in Carla's favorite color: Royal blue. They had a budget of just $4,000 for the entire affair, so they knew they would have to be creative. Carla's first decision was to place blue taper candles on each table, along with napkins that had the couple's names and the wedding date imprinted in blue—two relatively inexpensive touches that vividly established the color theme. To reinforce this theme and create a visual focal point, she also decided to use royal blue place settings for the bride's table.

While Carla wore the traditional white, the rest of the

wedding party picked up the royal blue theme. "My sister wore a beautiful royal blue satin dress for her own wedding, several years earlier," Carla explains. "For our wedding, my mother and sister made all of the bridesmaids' and candle lighters' dresses with the same royal blue satin fabric." Royal blue ties on the groom, groomsmen, and ushers completed the picture.

The wedding cake, which Carla's cousin baked, proved to be the pièce de resistance of the wedding. Carla gave her cousin a piece of her bridal veil material, which she used as a pattern for the icing on the cake. "She put the lace over the white frosted cake, then airbrushed royal blue frosting over the lace, so the cake was covered with delicate blue-lace frosting," Carla remembers. "It was awesome! I have one picture that I absolutely love of the reception tables all decorated, including the bride's table with blue glass place settings. The cake table is in the background—serving as a perfect focal point for bringing together the royal blue theme."

Carla and Richard's other family and friends got into the act, as well. As word spread about the royal blue wedding in the offing, many guests decided to come dressed in blue—especially the women, who arrived draped in a variety of royal blue gowns and dresses.

"It was an evening wedding, and the sequins on the dresses

really sparkled in the light—an effect that looks especially gorgeous on the video," says Carla. "When the reception finally ended, we posed one last time while the guests all took photos. Then everyone waved good-bye as we walked to our pickup truck to leave for our honeymoon."

We can't help wondering if the truck was royal blue, too.

Wedding Now, Party Later

Planning a wedding can frazzle the calmest and most organized of couples. But as we keep noting, there are a lot of ways to get married. Imagine this scenario, for instance: You throw an intimate, totally stress-free wedding for your closest family and friends in an exotic location, complete with all the bells and whistles, then follow it up with a huge, blow-out for everyone who couldn't make the wedding—and pull the whole thing off for under $6,000!

That's exactly what Janet and Don did. "After talking it over carefully, we decided to have a small destination wedding in Florida, and invite only our closest family and friends," explains Janet. "Having the wedding away from home was a great way to keep the guest list down to just those people we wanted to be there. Luckily we knew our families would make it a priority to attend."

The couple still had all the special touches they'd always dreamed of: A wonderful setting, with beautiful décor and music, as well as a fabulous meal. But because they held down the size of the guest list—the surest way to keep wedding expenses under control—the total cost for their Florida ceremony and reception was just $5,000. "The best part was, we were able to spend so much time with all of our guests," says Janet, "both at the actual event, and also in the days before and after the wedding, since we were all staying at the same hotel."

That summer, several months after they tied the knot, the couple threw a very big, very casual party for everyone they ordinarily would have invited to their wedding, had they been married in Janet's hometown. "The party was a lot of fun but had absolutely none of the stress involved in planning a wedding," Janet recalls. "I felt free to invite whoever I wanted, because the celebration was so casual that we didn't need to worry about getting a head count. And since it didn't have the structure of a formal reception, people who had other obligations were perfectly free to arrive late or leave early if they needed to, rather than miss out on the event entirely."

The party was held at the home of Janet's parents. "It was definitely *not* a traditional reception—more like a huge backyard barbecue for about eighty people," says Janet. "My

extended family contains lots of little children who we love, but who we didn't want at my formal wedding. And since both of our families are more comfortable with casual events, it seemed ideal to have a big, summer outdoor affair."

Don and Janet rented a canopy to provide some shade and had all the traditional summer picnic activities—volleyball, horseshoes, and lots of great food. The pictures from the Florida wedding were displayed as a slideshow on a computer throughout the party, so that guests could wander over and view them at their leisure.

"Not only did everyone have a great time, but we saved significantly over the costs of a traditional wedding reception," notes Janet. "We prepared all of the food ourselves. There was more than enough food and alcohol for everyone—and yet, all told, the celebration cost us less than $1,000. Best of all, as people were leaving, they asked us if we were planning on having an anniversary bash next summer. I'd say that's the ultimate sign of a successful wedding party!"

Barefoot on the Beach

Giovanna and Sebastian had a choice: To have a full-scale wedding at their home in Arizona, which would require going into debt and skipping their honeymoon; or to make their wedding

into a honeymoon by getting married in an exotic spot with just a few close relatives and friends in attendance.

It wasn't a difficult decision. "We were engaged for a year and a half, and after thinking through the options it became clear that what we really wanted was an intimate destination wedding with no big wedding party," says Giovanna.

Organizing the trip took a good amount of planning, including "lots of on-line searches and lots of phone calls." Eventually the couple settled on the surfer's paradise on the north shore of Oahu in Hawaii. "We were getting married in early December, which is the perfect time of year there," says Giovanna. "It wasn't too crowded, but the pipeline was huge, so there were a number of surfers hanging around."

The couple flew to Oahu on a Thursday, with the wedding scheduled for the following Monday. They were accompanied by only their daughter and Giovanna's mother, and were joined in Oahu by a close family friend who lived on the island. "We knew Sebastian's parents wouldn't be able to make it," adds Giovanna. "They just couldn't get away—but they were fine with that, as were we. Everyone else who couldn't attend understood, as well. Both of our families realized that the truly important thing was that two people were being joined together forever."

Their little group had a room on the twentieth floor of the

resort they were staying at. On the morning of the wedding, they woke to wind and rain lashing against the windows. "We were a little worried at that point," Giovanna admits. Suddenly the hotel fire alarm sounded, and they were told they had to evacuate the building immediately. Bracing themselves for the stormy weather outside, they walked down ten flights of stairs before the all-clear sounded. "It turned out to be a false alarm," chuckles Giovanna.

The couple went back to their room and continued getting ready. The marriage ceremony was set for three o'clock that afternoon, with an hour of photos to be taken beforehand. Miraculously, as they headed to the photo session the rain stopped and the sun came out.

"The photos were perfect," says Giovanna. "When the photographer finished, we got married on Sunset Beach, at sunset—which turned out to be absolutely beautiful, with all the clouds glowing orange and red! The ceremony was short and sweet, and very intimate. Everyone was in bare feet. I wore a traditional ivory wedding gown with a lei on my head, and my husband wore a beautiful suit and a traditional Hawaiian leaf garland. I carried another lei as a bouquet, which we both wrapped around our hands during the ceremony. As soon as it was over, the rain started up again. Actually, being from Ari-

zona, we found the rain quite enjoyable. And I've heard since then that Hawaiian rain on your wedding day is a blessing from the gods."

Following the ceremony, their friend treated the group to a fabulous buffet at Turtle Bay Resort. "Everything was just beautiful," recalls Giovanna. "I went to the buffet in my wedding gown and flip flops. Everyone was looking over and congratulating us. It was fun, quiet, and simple. They even had a small cake."

Next came an eleven-day Oahu honeymoon. Giovanna's mother and their daughter bunked with their friend, leaving Sebastian and Giovanna free to enjoy each other in their own island paradise. "We just concentrated on having a good time together," says Giovanna. Particularly relaxing was the knowledge that their entire wedding and honeymoon had cost just $6,000—including airfare, hotel, and Giovanna's wedding gown.

"It was an unforgettable wedding," says Giovanna. "The whole thing went smoothly and perfectly, in spite of the rain and the accidental hotel evacuation on our wedding day! I highly recommend the idea of a small destination wedding with only a couple of guests. It keeps things simple and relaxed, and allows for total enjoyment of the day and the event."

Marriage, Italian Style

"My wife, Tricia, and I were vacationing in Sienna, Italy, in late September of 2001," recalls Peter. "Our flight overseas had actually been delayed a week because of the horrific events on September 11. We were sitting at a table at Il Campo in the central piazza, savoring lunch and feeling relieved that we'd been able to make it to Italy at all." The piazza where they were dining was lined with restaurants, each with myriad outdoor tables facing the center of the huge square. "People of all sorts promenade in front of the outdoor tables—much to the delight and entertainment of the diners," Peter explains. "Our table fronted the promenade area, and we were enjoying the sight of the world going past."

As they sat there, they suddenly became aware that something special was approaching, because they heard the sound of people clapping. The applause grew closer and closer, and soon a couple appeared: A bride in a beautiful white gown, and her groom dressed to the nines in formal attire. "We joined in the clapping to congratulate the couple and wish them well," says Peter. "A photographer was chasing them around snapping pictures, and a few other people were accompanying them as part of their entourage. And then, as quickly as they appeared, they were gone."

Later, as Peter and Tricia headed back to where their car was parked, they spied the couple talking nearby, completely by themselves. As they got closer, they could hear that the bride and groom were speaking English—and with a distinctly American accent. "Whether they were from Boston or the Bronx, we couldn't be sure. But there was no doubt about it, they were as American as we were," says Peter. "Tricia, being Tricia, couldn't stand not knowing what the deal was. So she went over to the couple, introduced herself, and asked what an American couple was doing in wedding attire, walking around the piazza in Sienna, Italy, on a beautiful day in September."

The couple explained that they were from Chicago. Once they'd agreed to get married, they'd begun planning an extravagant wedding. The more they planned, however, the more they became concerned about the escalating cost of the whole affair. When the price tag climbed past $80,000, they decided it was time to explore other options. Searching on-line, they stumbled across the Web site of a woman who specializes in helping people plan a wedding in Italy or any number of other European locations. She would arrange to take care of the legal mumbo-jumbo, secure the photographer and the venue for the ceremony, find a place for the couple to stay, and so on.

The couple had invited their parents and several friends to

travel over to Italy with them, but the friends backed out at the last minute, fearful of flying after the 9/11 attacks. The couple and their parents, however, decided that the terrorists weren't going to deter them from their appointment in Sienna. They all flew together to Italy, the couple got married as planned, and then, as part of the tradition in Italy, they promenaded on the main square of the town they were married in.

"They were having a ball," says Peter. "They clearly had no regrets whatsoever about tossing the $80,000 event, or the fact that they didn't get married in front of all their friends back in the States. This was their moment, their life-changing event, and they were clearly focused on each other." The couple also confided to Peter and Tricia that the $60,000 they saved by getting married in Italy would be going toward the down payment on their home.

"Tricia and I were so impressed with what they'd done," smiles Peter. "They truly got married their way—and I think they got it exactly right."

CONNECTING WITH YOUR GUESTS

*a*s we've noted throughout this book, putting your own stamp on your wedding is a way for you, as the bride and groom, to express your own personalities and feelings at this very special time. But that's not all: By sharing a bit of yourselves with your guests and finding ways for them to express themselves in return, you're providing a way for your family and friends to draw closer to you and to one another. Following are several stories of how different couples reached out and connected with their guests—and vice versa—to create a sense of community that has continued to resonate long after the wedding day itself.

The Bells are Ringing

Katherine and Scott got married on the first day of May at a historic old club in East Hampton, New York. Leading up to their wedding there had been seven consecutive weekends of rain, but the weather on their wedding weekend was perfect—mild, sunny, and gorgeous. "We had an old-fashioned wedding," Katherine recalls. "The ceremony was in the early afternoon, after which we hosted several hundred guests for a luncheon in a wonderfully sunlit room. My parents and my in-laws were seated at our table, along with my husband, Scott, on my left, and my ninety-year-old grandmother—who I'm *extremely* close to—sitting on my right."

Midway through the four-course meal, Katherine's father stood and gave a heartfelt toast to the couple. Then Scott's father stood and gave a beautiful toast of his own. "That opened the floodgates," says Katherine. "For the next hour and a half, people all around the room stood up in random order to give the most gorgeous toasts I've ever heard. A lot of my family and friends are either writers or lawyers, and they all tend to be very verbal. Some of the toasts were funny, others were sentimental. Some people talked about the meaning of marriage, others about their hopes and dreams for my husband and me."

The toasts started winding down, until finally the last silver-tongued guest had had his say. That's when Katherine's grandmother, resplendently attired for the occasion in a bright yellow suit and black hat, got up to speak. The room fell respectfully silent. But what could this sweet elderly lady say about her beloved granddaughter that hadn't been said by the erudite and eloquent guests who'd gone before her? She looked around at everyone, drew in a deep breath, and then began half-talking, half-singing the words to "For Me and My Gal."

Katherine wasn't sure exactly what her grandmother was trying to do—but before she and Scott could figure out what was going on, everyone else at the reception had suddenly risen to their feet and burst into full-throated song, joining Katherine's grandmother in singing "For Me and My Gal" in its entirety.

"It turned out that my grandmother—knowing that she couldn't compete with all the other toasts being made that day—had quietly passed around the lyrics to all of the guests before the wedding." says Katherine. "Her standing and beginning that song, and having it suddenly picked up by every person there, was one of the most touching moments Scott and I have ever experienced. It was a wonderful sendoff to a great day—and it's a memory of our wedding, and of my grandmother, that we'll treasure forever."

The "Ice Breaker Quiz"

Every time Marsha attended a wedding, she found herself making mental notes of special touches she thought were beautiful or meaningful—touches that she wanted to consider for her own wedding. Maybe she'd use them "as is," or maybe she'd alter them to fit her particular situation—but they were always there, in the back of her mind.

One particular problem that kept nagging at Marsha was how much time people spent simply waiting around at weddings. In addition, she says, "I was intrigued by the things brides and grooms did to help out guests who didn't know each other well, by devising ways to bridge the small talk divide."

One day, Marsha and her fiancé, Robert, went to a wedding where the bride and groom had created a quiz for their guests to play to help pass the time while the wedding party was having their photos taken and the guests were seating themselves at the dining tables. The quiz focused on how well the guests knew the couple that was getting married. Marsha and Robert were sitting at a table with several people they had never met, and the game helped jump-start the conversation in a big way. "It was a lot of fun," recalls Marsha, "and we really got to know the people sitting with us."

When it came time for Marsha and Robert to tie the knot, they decided to create a similar sort of quiz. Before the start of the reception, they arranged to have someone place a sheet of paper on each table containing a list of questions such as, "Where was our first date?" "Which group of three people introduced us?" and, "His family knew it was getting serious when" Each question had a matching set of multiple-choice answers.

"All of the questions involved things that at least one or two people at each table were likely to know," says Marsha. "We were amazed at how well the game was received. The lively discussions that took place as each question was asked and answered proved to be a terrific ice breaker for the people at each table."

Time and again during the wedding, people raved to Marsha about how much fun the game had been. The best comment came from one of Marsha's closest friends, a single woman who had traveled across the country to attend the wedding. The friend told Marsha that she had come to the wedding with some trepidation, because she was worried about being alone and lonely—but that she'd had a wonderful time talking with Marsha's other friends, thanks in large part to the ice breaker quiz.

"It made my day to know that this special friend, who had

made such an effort to come to my wedding, had a wonderful time," says Marsha. "And it was great knowing that all the other guests enjoyed the wedding so much, as well."

Wishes of Love, Kept Forever

One of the most special and memorable parts of any wedding is the love and support that friends and family bring to the occasion. Many couples also take the extra step of creating tangible ways for those close to them to express this love. Whether this is a traditional guest book where people can write brief thoughts and wishes for the bride and groom, or a more elaborate way of letting guests express themselves, the result is often a wedding-day keepsake that the couple will cherish for the rest of their lives.

Laura and Jim asked each of the guests at their wedding to write their favorite inspirational words for the couple on a small scroll of paper. "People wrote poems, famous sayings, and some not-so-famous sayings!" says Laura.

Here are a few of their favorites:

"When you do the common things in life in an uncommon way, you will command the attention of the world."

"To get something you've never had, you must do something you've never done."

"Shoot for the moon—for even if you miss, you will land among the stars."

All the scrolls were then placed in a glass vase, which now resides in the couple's living room. Every now and then, on a quiet evening at home, Laura and Jim will each reach into the vase, pull out a few scrolls, and read the words of wisdom offered by their friends and family on their wedding day.

"The words themselves are wonderful, and so is the knowledge that all these people believe so strongly in the union we've committed to," says Laura. "It helps keep us constantly inspired in our marriage—and in life."

Sweet Pages

Kelly had been married to Mark for nine years, but she can still remember receiving her favorite wedding gift as clearly as if it had appeared on her doorstep yesterday. She and Mark had had a large wedding, complete with more "bells and whistles" than they'd really wanted. Both sets of parents had always hoped their children would get married on a grand scale, so

the couple went along with their dream. As it turns out, the bride and groom enjoyed their big day immensely; it was truly theirs, and very beautiful. Even though there were many parties and much fanfare, the couple ultimately felt blessed that they were able to share their excitement with their many guests.

The "sharing" aspect spilled over into the gift realm, as their guests went all out in their choices of wedding presents. Kelly and Mark were delighted but also overwhelmed by the generous outpouring from everyone involved. Amid the many gifts, however, one stood out from all the rest—and continues to stand out, years later. It's a simple homemade book of favorite recipes from her mother's closest relatives and friends. Each entry was lovingly handwritten by the person who was sharing the recipe. Today, the book is stained and dog-eared after nearly a decade of cooking from its pages, but Kelly and Mark continue both to treasure the gift, and to use it on a regular basis.

The Gift of Giving

When the time came for them to tie the knot, Caroline and Noam weren't completely comfortable receiving an onslaught of wedding gifts. As Caroline says, "We knew our friends and

families wanted to give us gifts and that it would give them and us pleasure. But at the same time, we felt overwhelmed by the seeming self-indulgence of it all."

Their solution was to select a unique type of gift registry—one that enabled them to assign a certain percentage of the value of each gift they received to one or more charities of their choice.

They had heard about charity registries through a friend of theirs, who happened to be the founder of the I Do Foundation. This foundation is dedicated to turning weddings into avenues of support for charitable organizations. Couples can go directly to the foundation, or they can link to the organization through WeddingChannel.com.

"Planning our wedding only served to reinforce our sense that the wedding industry can be a massive conveyor belt," says Noam. "Charitable registries provide couples with a creative way to make their weddings their own, while at the same time giving back to those who are less fortunate."

Caroline and Noam's guests could still buy the bowls, sheets, and camping tent that they had registered for. But in an agreement with the I Do Foundation, the stores that sell these gifts donated a percentage of the value of each purchase to the bride and groom's identified charities. The couple themselves used some of the participating businesses as well. "Even some

of what we spent on our invitations went to our charities," notes Caroline.

The couple also let it be known that they would be more than happy if guests chose to forego giving a wedding present to them completely, and instead made a charitable contribution. To facilitate this, an easy process had been set up on the foundation's Web site that allowed guests to make donations in honor of the newlyweds, either to the couple's chosen charities or some other charity.

The couple was very pleased with the entire arrangement, adding that they also got positive feedback from their families and friends. Caroline summed it up this way: "Those who wanted to give us plates had the option of selecting items off our registry and having some of the proceeds go to our charity. And as for those who wanted to give directly to charities, that was fine, too. Everyone could do what felt right to them—and at the same time, we all felt good about giving something to others."

Now, *that's* something to celebrate.

EMILY POST, 1872 TO 1960

Emily Post began her career as a writer at the age of thirty-one. Her romantic stories of European and American society were serialized in *Vanity Fair*, *Collier's*, *McCall's*, and other popular magazines. Many were also successfully published in book form.

Upon its publication in 1922, her book, *Etiquette*, topped the nonfiction bestseller list, and the phrase "according to Emily Post" soon entered our language as the last word on the subject of social conduct. Mrs. Post, who as a girl had been told that well-bred women should not work, was suddenly a pioneering American career woman. Her numerous books, a syndicated newspaper column, and a regular network radio program made Emily Post a figure of national stature and importance throughout the rest of her life.

"Good manners reflect something from inside—
an innate sense of consideration for others
and respect for self."
—Emily Post